THE

STROUDWATER

AND

THAMES & SEVERN

CANALS

From Old Photographs

volume three

EDWIN CUSS & MIKE MILLS

To the memory of Stanley Gardiner.
Many years ago he inspired us and encouraged us to have an interest and
enthusiasm for the history of our local communities and the area covered by
these two canals.

AMBERLEY

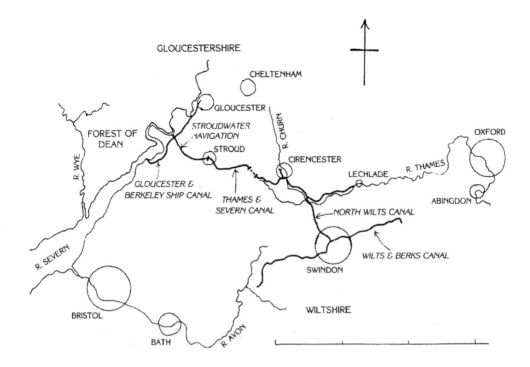

First published 2013

Amberley Publishing
The Hill, Stroud
Gloucestershire, GL5 4EP

www.amberley-books.com

British Library Cataloguing in Publication Data.
A catalogue record for this book is available from the British Library.

ISBN 978 1 84868 911 4

Typeset in 10pt on 12pt Sabon.
Typesetting and Origination by Amberley Publishing.
Printed in the UK.

Contents

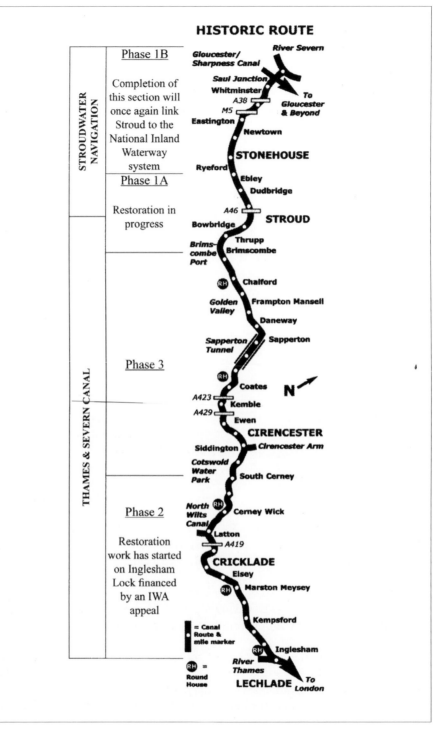

HISTORIC ROUTE

STROUDWATER NAVIGATION

Phase 1B

Completion of this section will once again link Stroud to the National Inland Waterway system

Phase 1A

Restoration in progress

THAMES & SEVERN CANAL

Phase 3

Phase 2

Restoration work has started on Inglesham Lock financed by an IWA appeal

River Severn
Gloucester/Sharpness Canal
Saul Junction
Whitminster
A38
M5
Eastington
Newtown
To Gloucester & Beyond
STONEHOUSE
Ryeford
Ebley
Dudbridge
A46
Bowbridge
STROUD
Thrupp
Brimscombe Port
Brimscombe
Chalford
Golden Valley
Frampton Mansell
Daneway
Sapperton Tunnel
Sapperton
Coates
A423
Kemble
A429
Ewen
CIRENCESTER
Siddington
Cirencester Arm
Cotswold Water Park
South Cerney
North Wilts Canal
Cerney Wick
Latton
A419
CRICKLADE
Elsey
Marston Meysey
Kempsford
Inglesham
River Thames
LECHLADE
To London

= Canal Route & mile marker

RH = Round House

The historic route of the two canals, showing the locations of communities, road crossings, connecting canals and phases of restoration.
(Reproduced by permission of the Cotswold Canals Trust)

4

Introduction

As time passes and events, attitudes and circumstances change over the years, the Cotswold Canals Trust has adjusted their restoration aims. At present these are fourfold:

- To promote for the benefit of the community the re-opening of the Cotswold Canals.
- To promote the restoration of the two waterways to give a balance between the needs of navigation, development, recreation, heritage, landscape, conservation, wildlife and natural habitats.
- To promote the use of all the towpath as 'The Thames and Severn Way'`.
- To achieve restoration of the Cotswold Canals as a navigable route from Saul Junction to the River Thames.

Now, since the books *Stroudwater and Thames & Severn Canals from Old Photographs* were published, Volume One in 1988 and Volume Two in 1993, restoration has proceeded with great and gathering pace.

The map of the Historic Route on page 4 shows the four restoration phases:
Phase 1A from Stonehouse to Brimscombe. This section is underway and funded by the Heritage Lottery Fund, Stroud District Council, British Waterways, and Cotswold Canals Trust members.
Phase 1B from Saul Junction to Stonehouse. This section will make the all important connection to the national waterways system and fundraising efforts are taking place.
Phase 2 from the Cotswold Water Park to Inglesham. This section has some parts where restoration has taken place for many years and this work continues. The towpath has been re-opened where possible and most significantly the length from Siddington to Latton.
Phase 3 from Brimscombe to Cotswold Water Park. This section will include major engineering projects such as the many locks up to the summit level on each side, the tunnel, and the water supply problem to the summit level.

This third volume is the completion of the trilogy of *From Old Photographs* of the two canals, the Stroudwater Navigation and the Thames & Severn Canal that are now referred to as the Cotswold Canals in many instances. Once again we have found that there are some sections of the canals with no new pictures, and other sections, at the important places along the routes, that have too many. This causes the pictures to bunch up but those that are used are thought to be worth reproducing. We recommend that Volume Three be read in conjunction with

Volume One and Volume Two in order to get the most comprehensive overall view. These three publications have resulted in close to eight hundred pictures being published and effectively exhaust the canal collections of Edwin Cuss and Mike Mills. It is hoped that they represent a major archive of local canal photographs.

For those wishing to gain a deeper insight into these canals there are some excellent books on the subjects.

Michael Handford, *The Stroudwater Canal* (Alan Sutton Publishing, 1979).

Joan Tucker, *The Stroudwater Navigation* (Tempus Publishing, 2003).

Michael Handford and David Viner, *The Stroudwater and Thames & Severn Canals Towpath Guide* (Alan Sutton Publishing, 1984 and 1988).

Humphrey Household, *The Thames & Severn Canal* (David & Charles, 1969; Alan Sutton Publishing, 1983; new edition Amberley Publishing, 2009).

David Viner, *The Thames & Severn Canal History and Guide* (Tempus Publishing, 2002).

Edwin Cuss and Mike Mills, *The Stroudwater and Thames & Severn Canals from Old Photographs Volume One* (Alan Sutton Publishing, 1988; reprinted Amberley Publishing, 2010).

Edwin Cuss and Mike Mills, *The Stroudwater and Thames & Severn Canals from Old Photographs Volume Two* (Alan Sutton Publishing, 1993; reprinted Amberley Publishing 2010).

Finally, for reference when reading these books we have included these timelines of the two canals. These show the most important dates when major events occurred on the canals in the past:

Stroudwater Navigation:

1775–1779	Construction period.
c. 1780–c. 1865	Profitable period.
1941	Last commercial traffic.
1954	Closed to Navigation but not abandoned.

Thames & Severn Canal:

1783–1789	Construction period.
1813	Parkend Wharf at Lechlade purchased.
c. 1800–c. 1885	Profitable period.
1895–1899	Thames & Severn Canal Trust restoration.
1901–1904	Gloucestershire County Council restoration.
1911–1912	Last traffic over the summit level.
1927	Abandonment east of Whitehall Bridge.
1933	Abandonment west of Whitehall Bridge.

In the period since the early 1970s modern restoration in varying degrees has taken place, with the formation of a canal society and then two trusts:

- In 1972 the Stroudwater Canal Society was formed.
- In 1975 the Stroudwater, Thames & Severn Canal Trust was formed.
- In 1990 the Cotswold Canals Trust was formed.

Gloucester & Berkeley Ship Canal

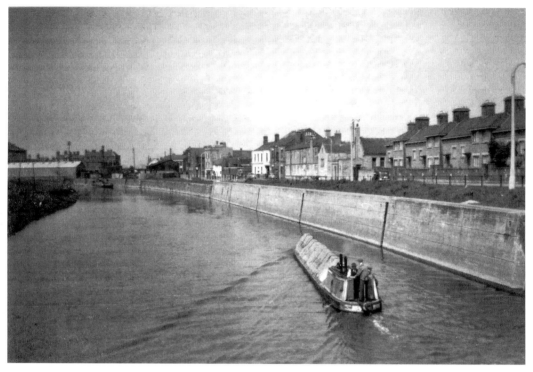

MOTOR LONGBOAT STARTING UP RIVER SEVERN, 1952. The longboat *Beech* of the Severn & Canal Carrying Co. has just left the lock out of Gloucester Docks onto the River Severn for a journey up to the Midlands.

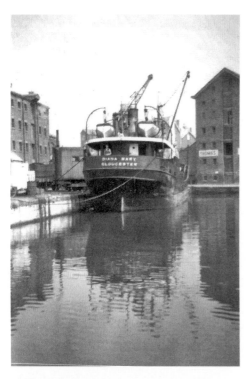

MV *DIANA MARY* IN GLOUCESTER DOCKS, 1952. This Gloucester-registered, 97-ton motor vessel was unloading fuel brought over from Swansea.

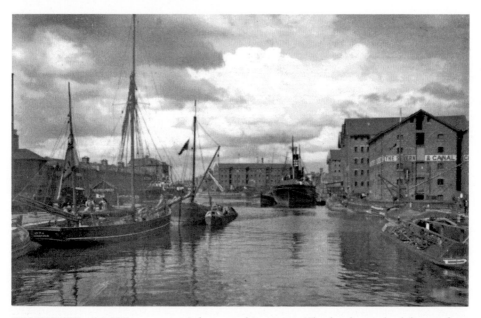

GLOUCESTER DOCKS, *c.* 1910. A busy working scene. The ketch on the left was from Barnstaple and in front of it is a trow unloading into a narrowboat. In the background is a steamer and on the right are narrowboats loaded with coal.

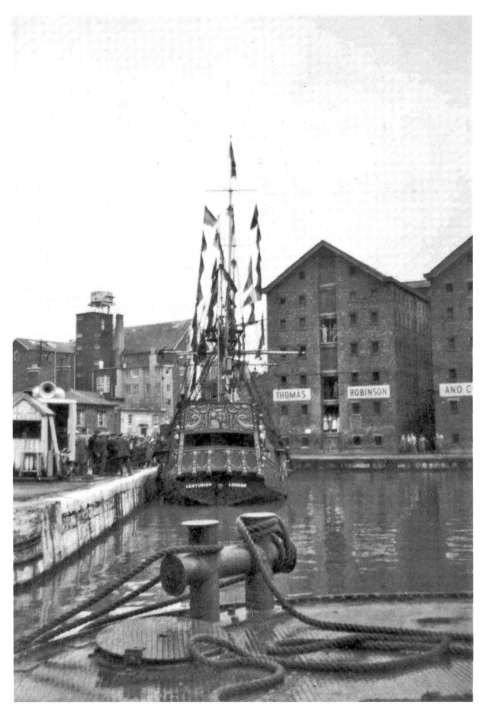

SPG *CENTURION* IN GLOUCESTER DOCKS, 1952. This was a galleon-style mission ship registered at Barry, of 21 tons. It was a replica of a ship from 250 years previously, built to celebrate the original vessel's voyage to America in around 1700. A civic welcome was held on board and on the quayside adjacent to the warehouse of Thomas Robinson & Co. The ship later sailed down to Portishead.

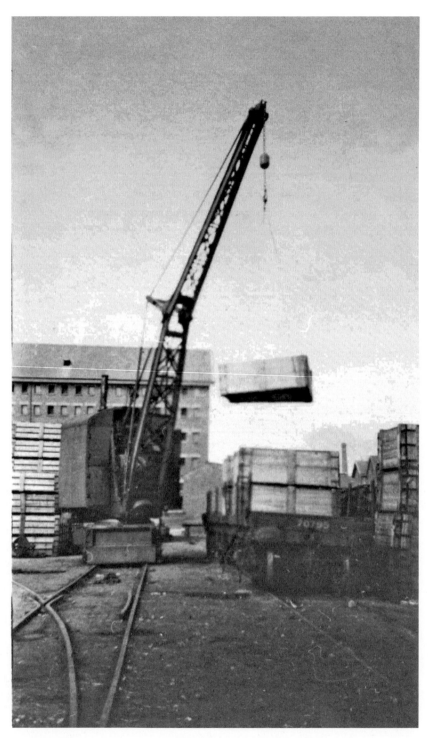

GLOUCESTER DOCKS, *c.* 1930. The steam crane loads wooden crates onto railway wagons. The crates probably came to the docks on board a ship along the Gloucester & Berkeley Canal.

UPPER BRIDGE AT FRAMPTON-ON-SEVERN, *c.* 1905. Note the trow on the left and the bridge-keeper's house with pillars on the right. The view looks down the canal to Sharpness.

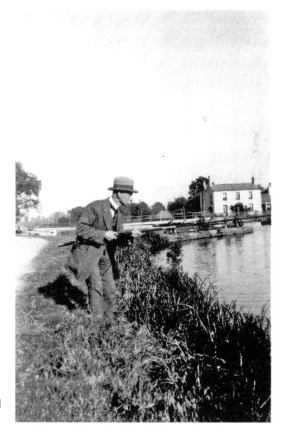

FISHING ON THE GLOUCESTER TO BERKELEY CANAL AT THE JUNCTION. Mr White hopes for a catch. The junction house is in the background and a footbridge crosses the canal. The Stroudwater Navigation joins and crosses here from the River Severn off to the left and on across and up towards Stroud.

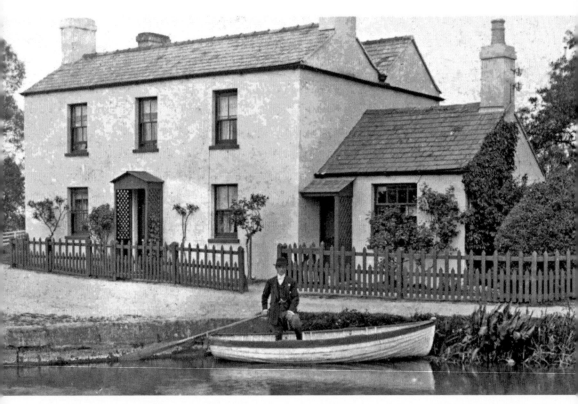

THE JUNCTION HOUSE AT SAUL JUNCTION, *c.* 1910. Probably it is the keeper's boat for getting about on the canals that can be seen moored in the Stroudwater Navigation as it leaves that junction.

Stroudwater Navigation

FRAMILODE LOCK, c. 1900. This is the first lock off the River Severn, and with the bottom gates open the high-tide level of the river is filling the lock chamber. Behind the man seated on the gate is a capstan, sometimes used to help wind boats into the lock in difficult conditions.

FRAMILODE TO STROUD

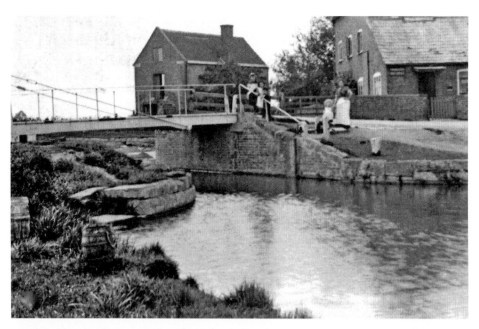

FRAMILODE BASIN, *c.* 1905. Framilode Lock was beyond the swing bridge, but the canal opened out into this basin where boats could load or unload or just wait for the right tidal conditions in the river before continuing with their journey. In the background on the left is a small warehouse and the lock-keeper or agent's house is on the right.

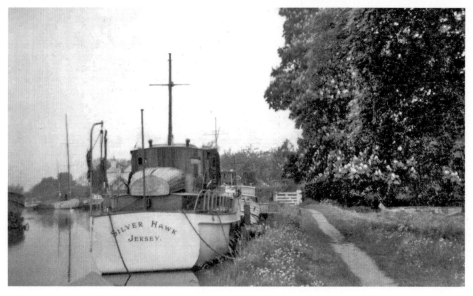

MOTOR CABIN CRUISER *SILVER HAWK*, 1952. This small, Jersey-registered pleasure cruiser is moored in the canal just above Saul Junction.

ABOVE SAUL JUNCTION, *c.* 1935. Looking back down the canal towards Saul, a line of houseboats are moored by the towpath.

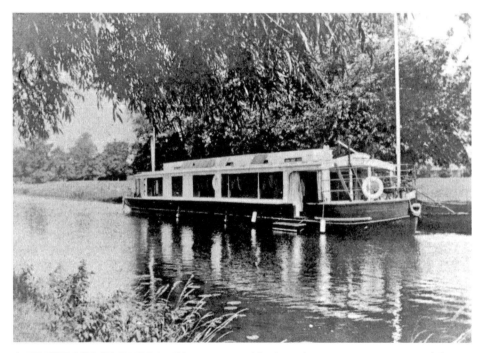

A HOUSEBOAT AT WHITMINSTER, *c.* 1905. The houseboat *Daisie* was converted from a barge.

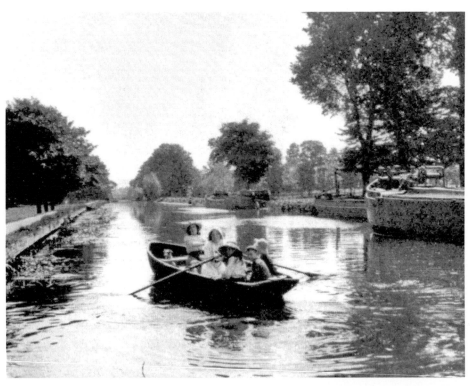

AT WHITMINSTER, *c.* 1925. Two ladies are rowing a small pleasure boat on the canal, which stretches up towards Walk Bridge.

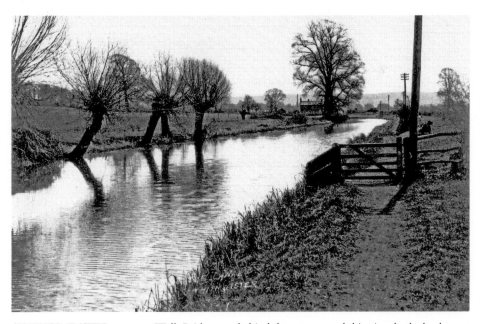

AT WHITMINSTER, *c.* 1930. Walk Bridge was behind the camera and this view looks back west round the curve to the junction.

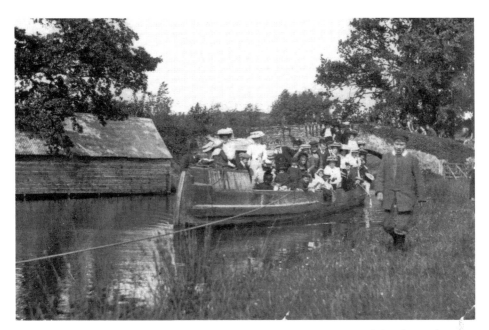

AT OCCUPATION BRIDGE NEAR WHITMINSTER, *c.* 1916. A group of church people are on a trip on the canal going west. Note the towrope across the foreground, which goes to the towing horse on the towpath off to the left. There is also a group of children in the background, sitting on the parapet of Occupation Bridge to watch the event.

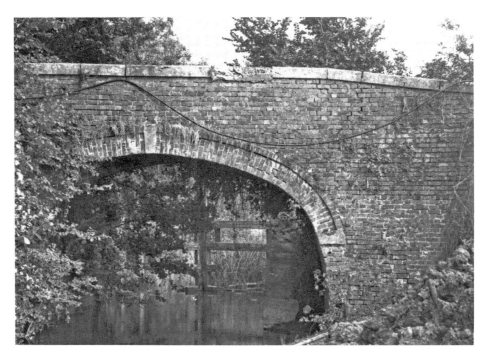

WESTFIELD BRIDGE AND LOCK, *c.* 1960. Westfield Lock can be seen through the arch of the bridge, over which a track linked up to the road and, many years ago, down to Meadow Mill.

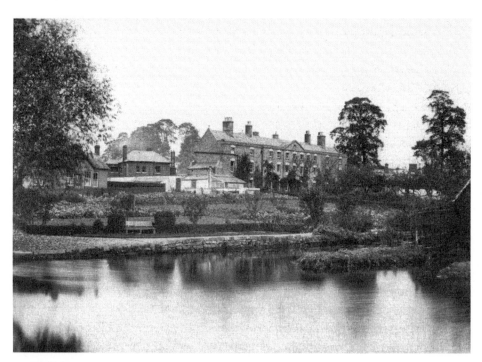

CHIPPENHAM PLATT AREA, *c.* 1905. The Oldbury Brook joined the canal here from behind the boathouse on the right. The Canal Co. ice-breaker was kept here and other areas here were the maintenance yard. The large building in the centre was the Wheatenhurst Union Workhouse.

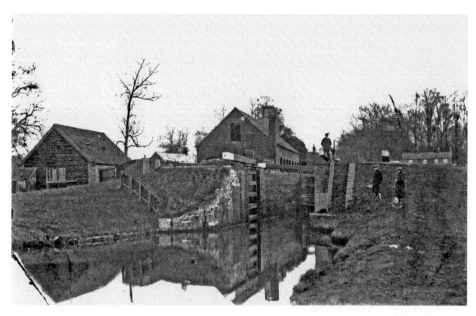

DOCK LOCK AT EASTINGTON, 1907. Dock Lock was the second of five locks within the mile where the canal met gently rising ground around Chippenham Platt. These five locks are Westfield, Dock, Pike, Blunder and Newtown.

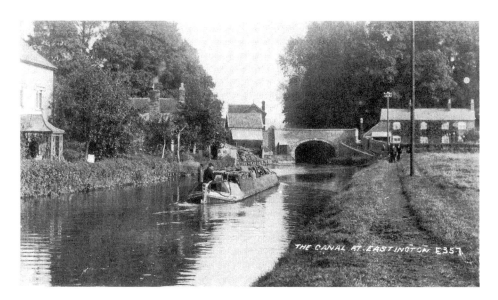

BELOW PIKE BRIDGE, 1910. A good working scene, with a horse-towed and fully-loaded narrowboat making its way towards Pike Bridge. Whiting's Wharf is on the left beside the bridge and Pike Lock is immediately above the bridge. The towpath crosses this bridge from the right-hand side to the left-hand side looking up the canal.

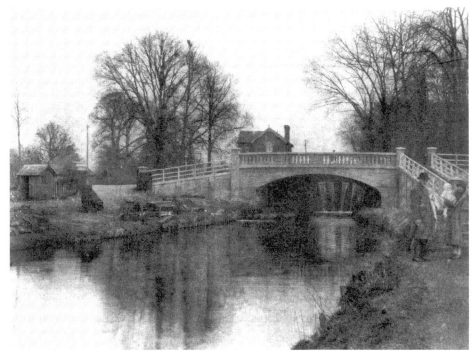

PIKE BRIDGE AND LOCK, c. 1925. A different ornately rebuilt bridge from the previous picture, but still with Whiting's coal wharf on left. Water pours over the bottom gates of the lock, seen through the bridge arch.

BELOW BLUNDER LOCK, *c.* 1910. The canal curves gently round towards the very small community of Newtown. A typical small Edwardian boat with an awning makes progress up the canal towards Blunder Lock, towed by the two men ahead on the towpath.

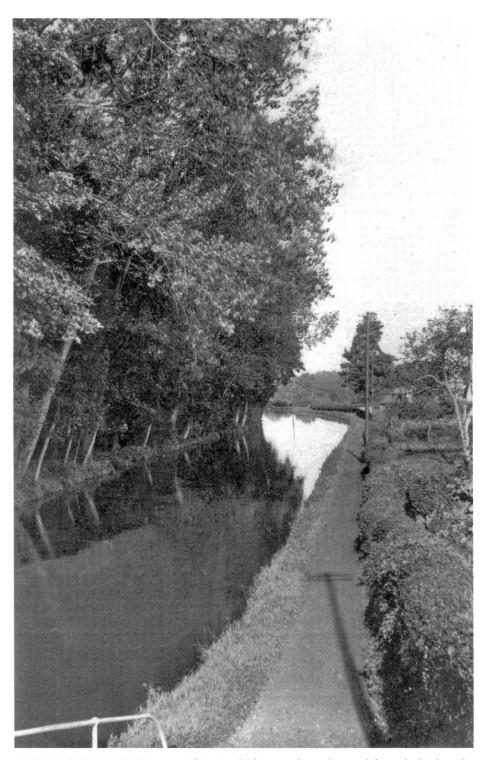

BELOW ROVING BRIDGE, 1908. This view looks west down the canal from the bridge. The towpath crosses the canal here.

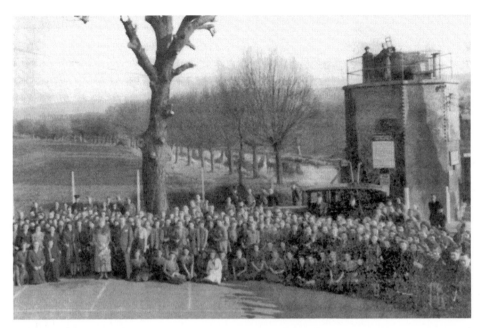

AT BOND'S MILL, 1941. Queen Mary visited Bond's Mill, where Sperry Gyroscope operated during the Second World War. The workforce was assembled in greeting and recognition of her visit. The pillbox was manned by the Home Guard unit from the factory. The canal stretches down and away in the distance along the line of trees.

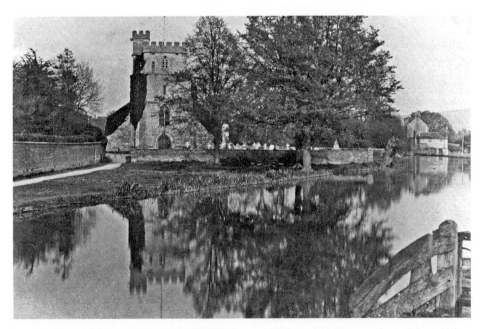

ABOVE THE OCEAN NEAR STONEHOUSE, 1909. This view looking up the canal was taken from Ocean Swing Bridge. Behind the camera was the large open expanse of water called the Ocean, where the railway line crossed the canal. St Cyr's Church is in the centre and the canal goes on towards Nutshell Bridge by the buildings on the right.

BELOW NUTSHELL BRIDGE, 1907. Nutshell Bridge, which is abutted to Bridge Cottage and can be seen in the distance, carried the access track down to Lower Stonehouse Mills.

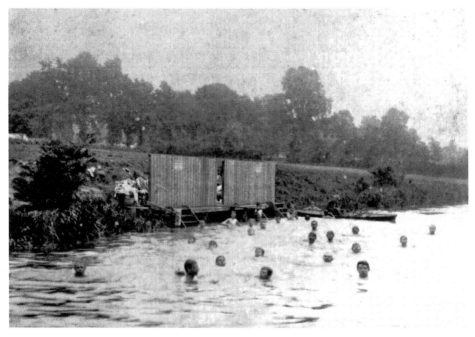

WYCLIFFE COLLEGE AT STONEHOUSE, c. 1920. The college boys are swimming in the canal. There are twenty-six boys with a teacher in the skiff in case anyone gets into difficulties. Behind the wooden fence was the changing area, giving a degree of privacy from the gaze of those who passed by on the towpath.

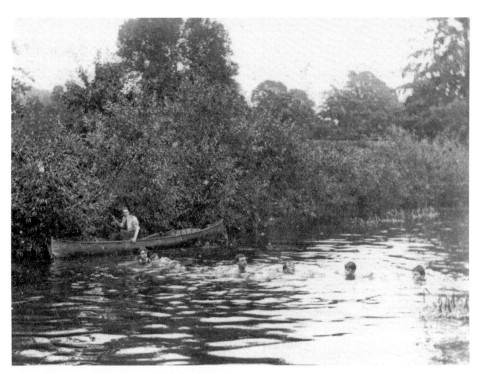

WYCLIFFE COLLEGE SWIMMING SPORTS, *c.* 1910. The boys are lined up in the canal for the start of a swimming race under the watchful eyes of a master in a canoe.

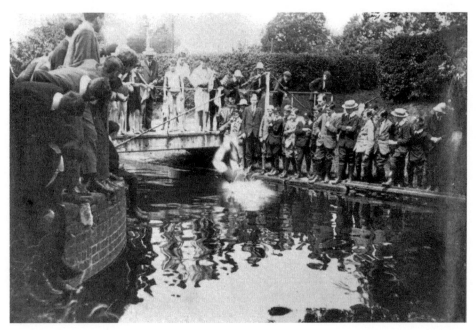

WYCLIFFE COLLEGE SWIMMING SPORTS, *c.* 1910. Boys are diving off the swing bridge, which gave access to the works at Upper Stonehouse Mills.

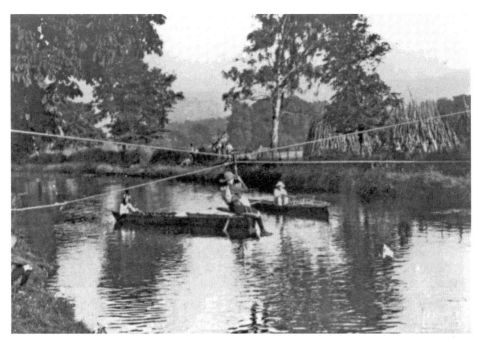

BOY SCOUT ACTIVITY AT STONEHOUSE, *c.* 1935. The scouts are using ropes and a bosun's chair device to cross the canal without getting wet. Note the timber on the opposite bank which was probably for the Brush Works at Upper Stonehouse Mills.

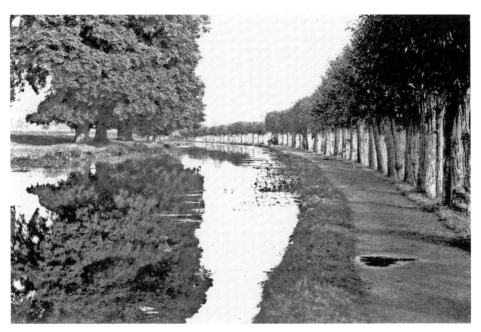

AT STONEHOUSE, 1908. The long line of pollarded willows edges the towpath where the canal curved gently round towards the railway bridge over the canal near Ryeford.

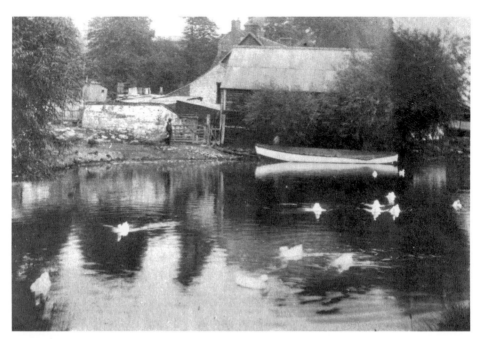

NEAR RYEFORD, *c.* 1910. This shows the boatyard slip below Ryeford Bridge.

ABOVE RYEFORD BRIDGE, *c.* 1965. The building on the right was the Anchor tied to the Nailsworth Brewery, but is now Tankard House, a private dwelling. The view looks east towards Stroud. Mains gas and water pipes are fixed to the bridge and Wycliffe Junior School is beyond Tankard House.

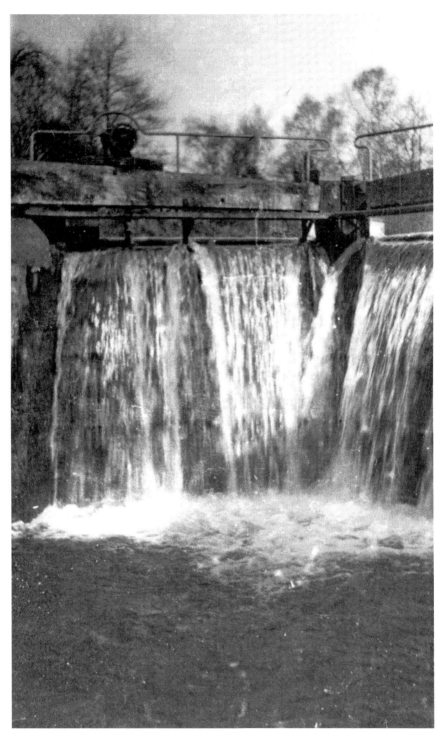

RYEFORD DOUBLE LOCK, *c.* 1930. The double lock was built in unstable ground and gave constant trouble to the company. The overspill of water at these bottom gates gives a good indication of the amount of water in the canal.

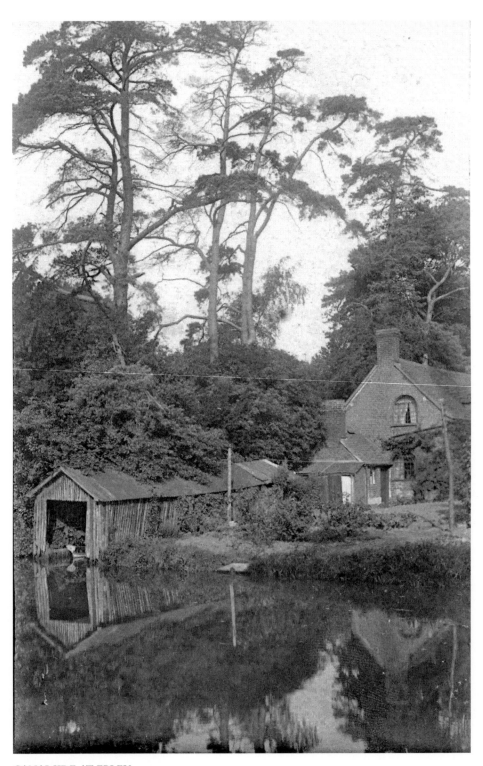

CANALSIDE AT EBLEY, *c.* 1915.

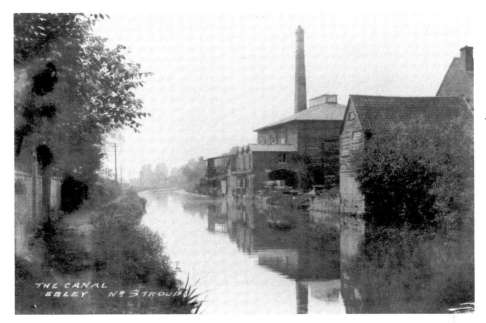

EBLEY SAWMILLS, *c.* 1910. This view looks west down the canal and shows the steam sawmills below Oil Mills Bridge. Timber for the mill was probably delivered and taken away by barge.

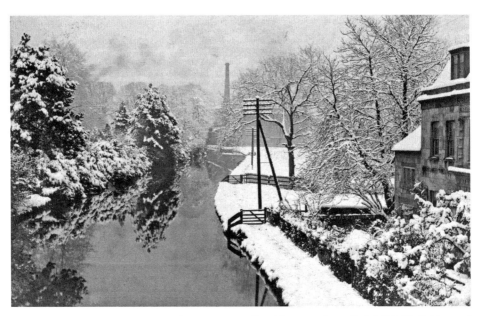

EBLEY MILL FROM BELL BRIDGE, *c.* 1915. Bell Bridge was also called Oil Mills Bridge and this view looking up the canal shows a lovely winter snow scene by H. Tanner of Ebley. Ebley Mill in the background is identified by the tall chimney, and on the right is Bridge House. Note the three towpath gates which preserved the company's control of their towpath so that no public right of way became established.

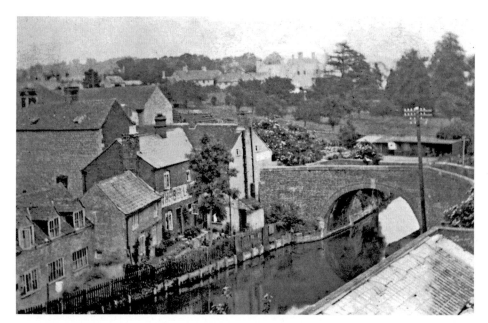

OIL MILLS BRIDGE, 1906. This bridge gave access down to the Corn Mill or Oil Mills. It was also called Bell Bridge as it abuts the Bell Inn and House. In the centre background can be seen the large Ebley House, later to become the orphanage.

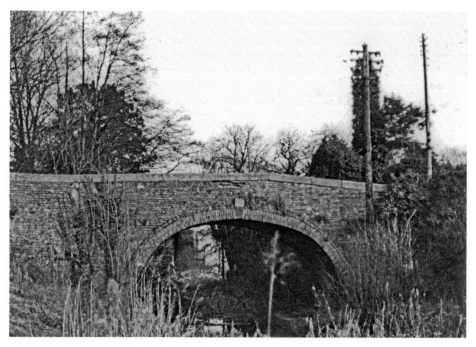

OIL MILLS BRIDGE, 1967. The bridge date stone above the arch keystone is marked 1808.

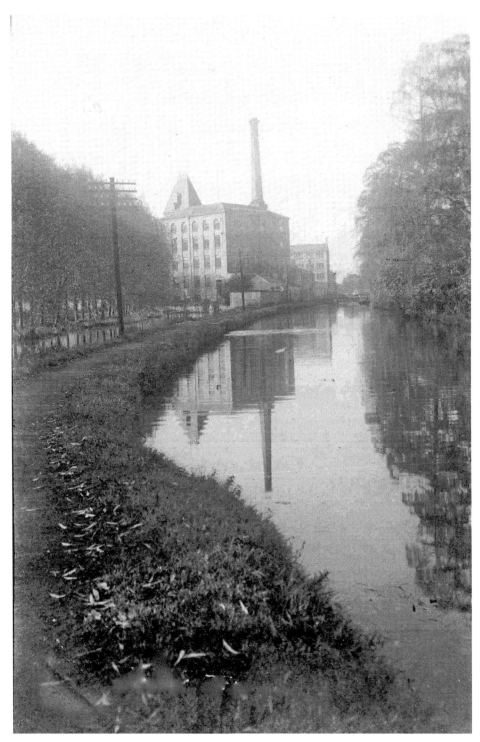

ABOVE EBLEY MILL, *c.* 1915. This view looks west and has the large buildings of Ebley Mill in the centre. Originally it was a woollen mill but is now the headquarters of Stroud District Council.

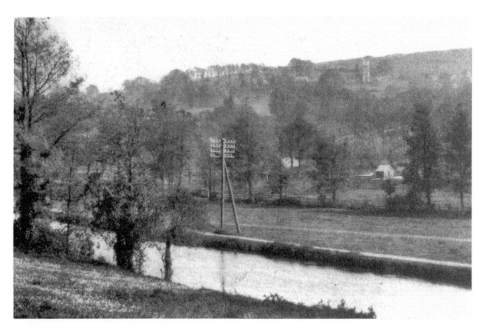

THE CANAL AT EBLEY, *c.* 1910. Looking south across the canal, with Selsley Church up on the distant hillside.

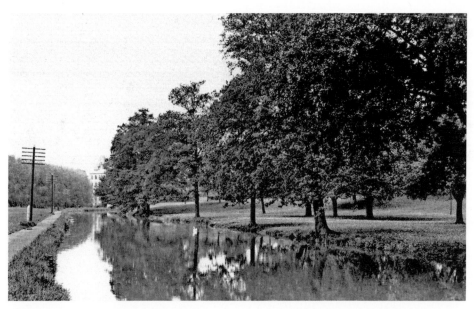

VIEW FROM HILLY ORCHARD BRIDGE, *c.* 1925. A footpath crossed the canal here running through from Dudbridge to Cainscross. Ebley Mill is in the distance of this scene looking west.

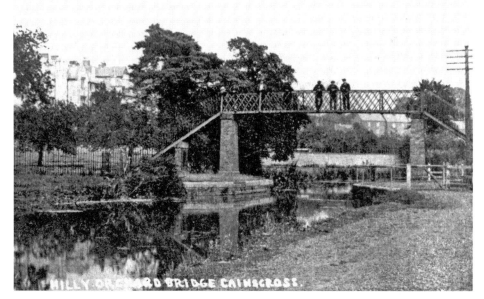

HILLY ORCHARD BRIDGE AT CAINSCROSS, c. 1900. The high-level iron lattice bridge seen here has a long, chequered history as an important footpath crossing. It has recently been restored to the high level having been lowered for many years.

DUDBRIDGE WHARF, c. 1915. It is not the best of pictures, but was thought worthy of inclusion. In the foreground two barges are in the canal by the large crane on the wharfside. There are piles of coal on the wharf to the left. The wharf was a triangular shape with the complex of Dudbridge Mills prominent in the background.

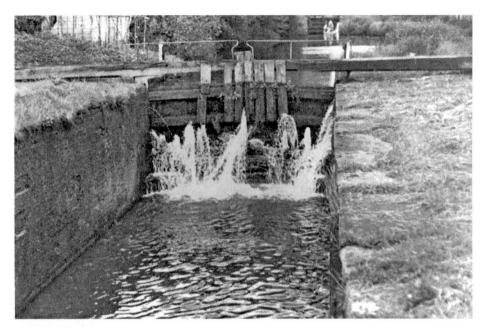

DUDBRIDGE LOCK, c. 1935. Dudbridge Lock and Foundry Lock beyond are the final two locks on the canal as it approached the Wallbridge Basin, about half a mile away. A large amount of water is evident, as it always was, escaping through the gates. It is hoped to install a small hydro-electric scheme here in the future to use the water.

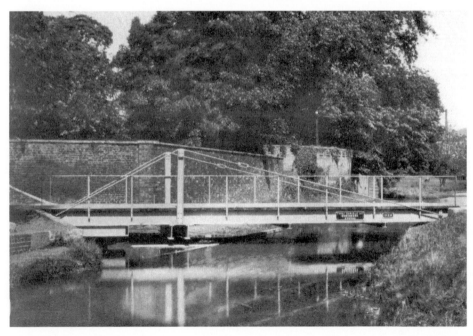

LODGEMORE SWING BRIDGE, c. 1930. This replacement structure was installed by Daniels Ltd of Lightpill in 1928, as the plate on the bridge shows. One of the tracks to Lodgemore Mill crossed the canal at an angle over this bridge.

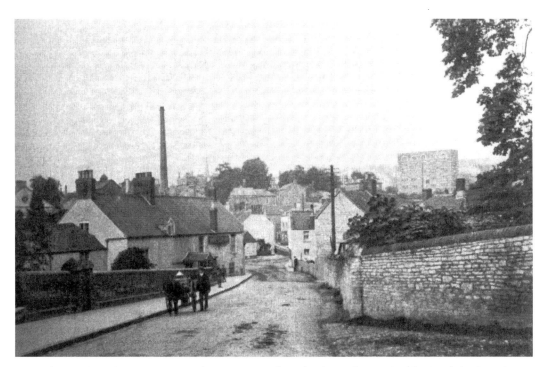

ENTRANCE TO WALLBRIDGE WHARF, *c.* 1910. This wharf was the terminal basin of the Stroudwater Navigation in Stroud. The road led down to the wharf and the Ship Inn was on the left. This layout is now drastically altered but the tall Stroud Brewery chimney and the Hill Paul building help to give some orientation.

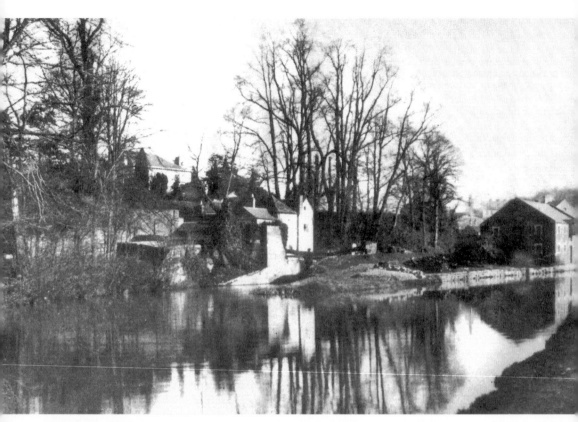

WALLBRIDGE JUNCTION, 1896. The terminal basin of the Stroudwater Navigation was off to the right and the warehouse was on the wharfside. It was into the side of this basin that the Thames & Severn Canal was joined and the first deep lock out of this basin, Wallbridge Lower Lock, can be seen in the centre of the picture.

Thames & Severn Canal

BELOW WALLBRIDGE UPPER LOCK, 1975. This is the curve between Wallbridge Lower and Wallbridge Upper Locks, and the view was taken from under the arch of the Bath Road Bridge over the canal. The building with the iron bars at the windows was once a part of Stroud Brewery, which was almost completely demolished in around 1970.

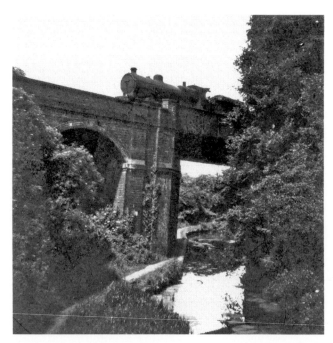

CAPEL'S VIADUCT, 1956. A train crosses the canal high up on Capel's Viaduct. The Stroud east–west bypass, Dr Newton's Way, now uses this bridge under the railway and the canal will be diverted through one of the other arches.

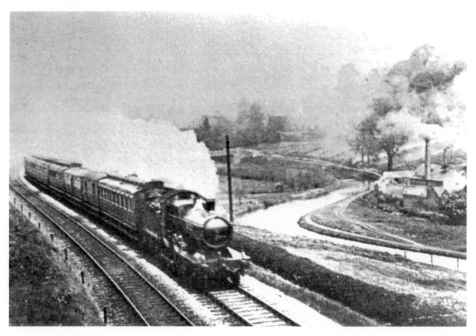

BELOW BOWBRIDGE, c. 1900. The canal curved sharply around Arundell Mill, which has plenty of smoke coming from the chimneys. The train is London-bound and pulling a set of clerestory carriages. The railway lines through the valley are never far from the route of the canal.

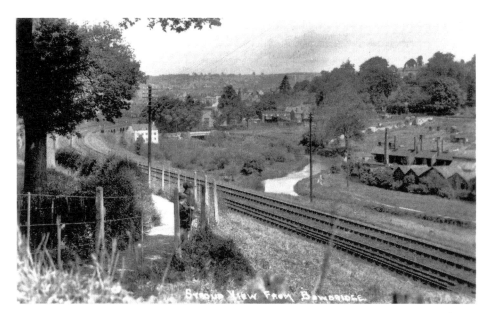

BY ARUNDELL MILL, *c.* 1935. A similar view to the previous picture but taken from a greater distance and showing more detail. Arundell Mill on the right is quieter and the railway line curving down to Stroud dominates the transport scene. Two small boys are in an excellent place on the path for watching the trains go by. Capel's Mill nestles in the curve of the railway lines down by the viaduct, in the distance.

ABOVE BOWBRIDGE LOCK, *c.* 1920. The trow belonging to T. Pearce of Brimscombe progresses down the canal, with the mast lowered in order to negotiate the bridges. The buildings on the left against the towpath were part of Bowbridge Dyeworks.

GRIFFIN'S LOCK, 1933. The canal below the lock has plenty of water even though this was the year of official abandonment of the western section. Note the banker engine up on the railway line running along up above the canal.

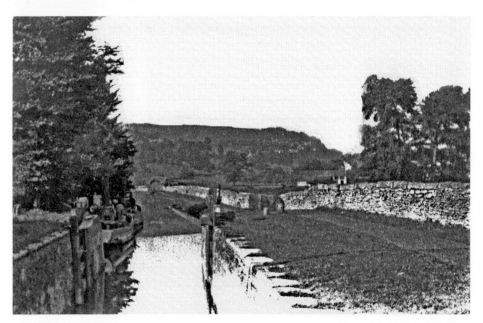

GRIFFIN'S LOCK, c. 1910. Some steam boats are moored below the lock and are probably down from the Abdela & Mitchell boat builders further up the canal at Hope Mill. In the distance is Stanton's Bridge and Stafford Mill.

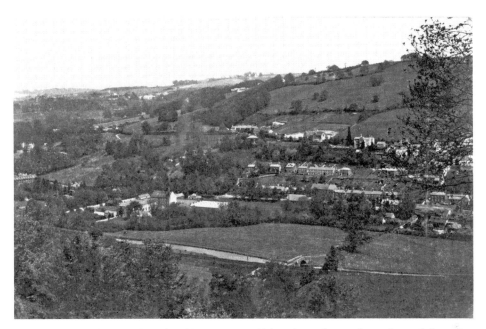

ACROSS THE VALLEY AT BAGPATH, *c.* 1925. Taken from the southern slope of the valley the canal and Bagpath Bridge are prominent in the foreground and Ham Mill is the complex in the left centre. Bagpath Bridge gave access down across the valley to the Phoenix Ironworks on the right and also to many other industries in the area.

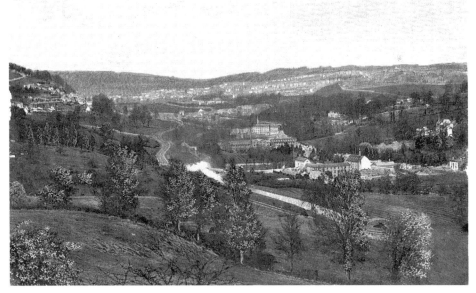

VIEW DOWN THE VALLEY FROM BELOW BAGPATH BRIDGE, *c.* 1915. This shows the railway line curving down the valley towards Stroud, and it is plain to see how this faster and more direct mode of transport eventually took over from the canal. The mills that can be seen on the right of the canal by the River Frome looking down are, Ham Mill, with smoke coming from the chimney, Griffin's Mill and Stafford Mill.

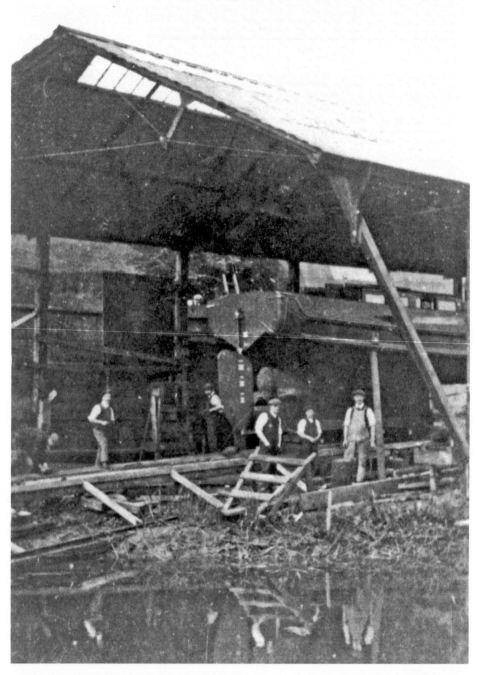

ABDELA & MITCHELL BOATYARD AT HOPE MILL, *c.* 1920. Edwin Clark established a boat building yard at Hope Mill and this later became Abdela & Mitchell. On the bank side of the canal above Hope Mill there was a large open-fronted shed with slipways down into the canal. Boats were launched into the canal at an angle because of their length. A boat can be seen under construction on the slipway in the shed. Hope Mill Lock was also known as Ridler's Lock.

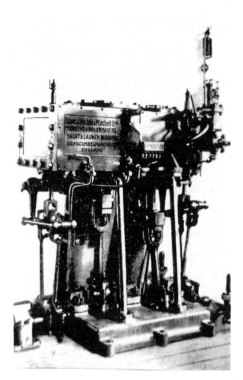

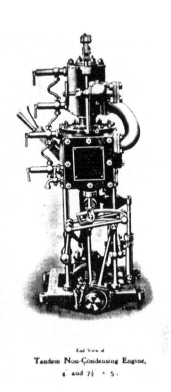

End View of
Tandem Non-Condensing Engine,
4″ and 7½″ × 5″.

LEFT: A COMPOUND STEAM ENGINE. The enging plate reads 'Isaac J. Abdela & Mitchell Ltd., yacht & launch builders, Brimscombe & Manchester, England'.

RIGHT: ABDELA AND MITCHELL TANDEM NON-CONDENSING ENGINE.

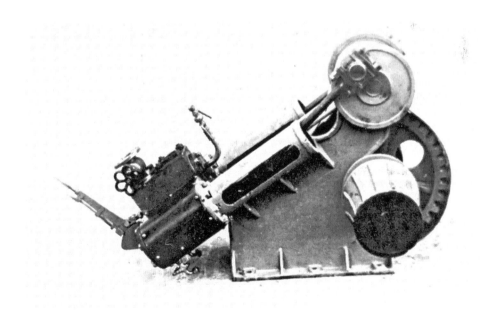

ABDELA & MITCHELL TWO-CYLINDER STEAM WINCH.

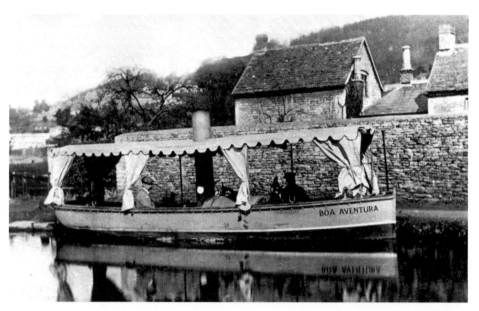

ABDELA & MITCHELL BOAT AT BOWBRIDGE, *c.* 1910. The *Boa Aventura* was a small steam river boat complete with canvas awning and side curtains. Most of these boats with Spanish names were destined for the South American river trade.

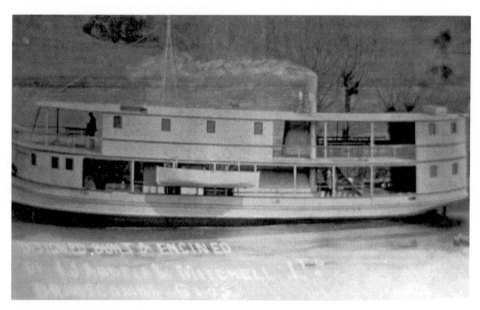

ABDELA & MITCHELL BOAT, 1906. The *San Juan* was a large double decked river boat with fixed cabins. She is seen here with steam up and is listed as 'designed, built & engined by I. J. Abdela & Mitchell Ltd., Brimscombe, Glos.'

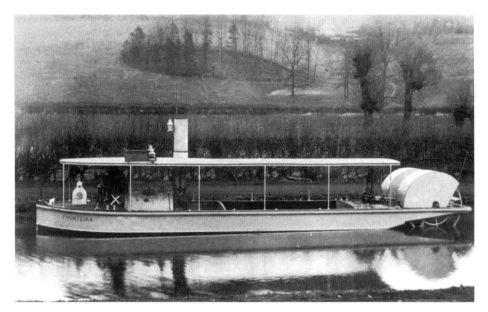

ABDELA & MITCHELL STERN PADDLE BOAT, *c.* 1910. The *Fronteira* was a medium-sized flat-bottomed stern paddle boat designed for shallow draft and to be used mainly for river cargo transport.

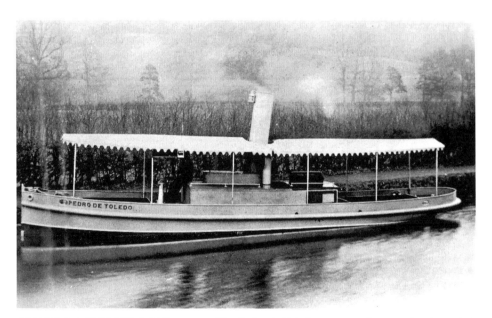

ABDELA & MITCHELL BOAT, *c.* 1910. The *Pedro de Toledo* was a small steam river boat. It is seen here on trial on the canal before delivery.

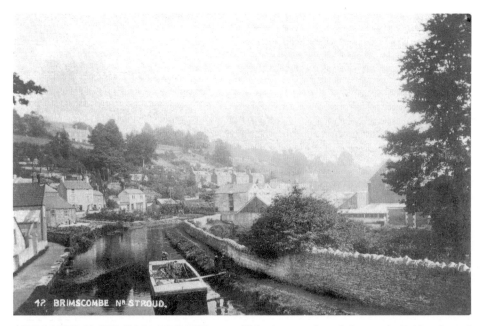

APPROACHING BRIMSCOMBE PORT, 1905. This view was from Brimscombe Bridge. Round the curve can be seen the Canal Company headquarters and warehouse building. On the right by the trees are the Brimscombe Upper Mill buildings.

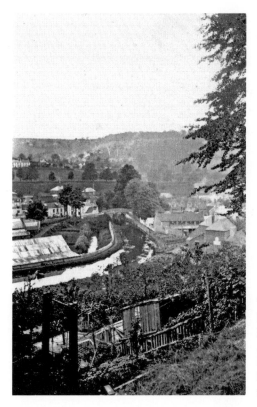

VIEW DOWN TOWARDS BRIMSCOMBE BRIDGE, c. 1920. This high-level view looks west, centring on Brimscombe Bridge. All of the buildings on the right of this bridge were demolished in the 1960s. The large expanse of corrugated iron roofing on the left was part of Brimscombe Upper Mill.

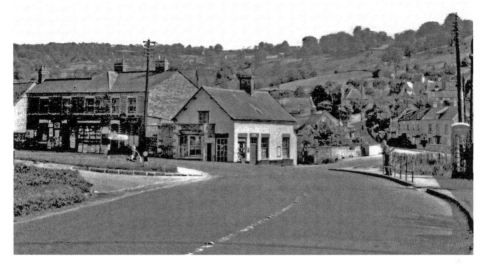

BRIMSCOMBE CORNER, 1955. This sharp corner on the main road at Brimscombe has been altered and nowadays is safer for the traffic. Brimscombe Bridge over the canal was demolished in 1949 but was situated down beyond the man standing at the bus stop by the telephone kiosk.

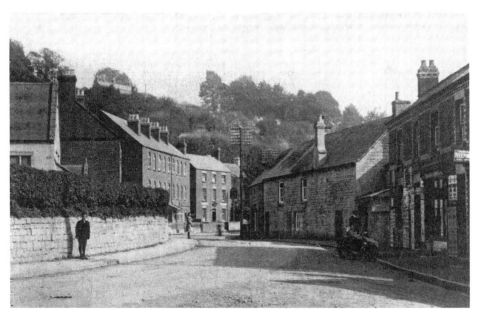

BRIMSCOMBE CORNER, c. 1920. The central building in the background was the Port Inn, a public house much frequented by the bargees and workers from the port, though there were also other public houses in the area.

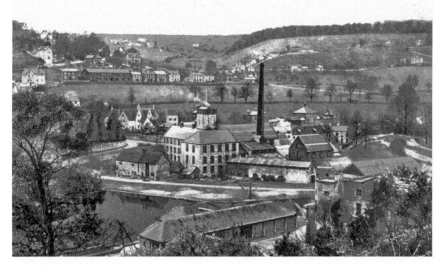

BRIMSCOMBE PORT, *c.* 1900. Looking down on the port from the northern slope of the valley, Brimscombe Upper Mill is prominent in the centre. The canal basin is in the foreground with the long low roof of the transit shed and the barge weighing machinery dock. The building comprising the company headquarters, agent's house and warehouse is on the right. The houses up on the bank in the background are in Victoria Road.

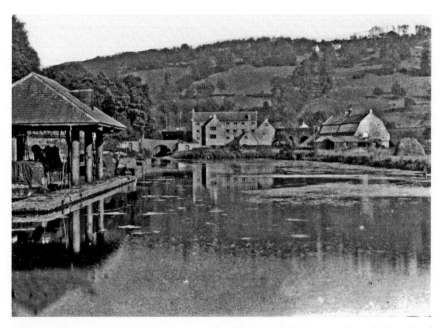

BRIMSCOMBE PORT BASIN, *c.* 1910. A lovely scene looking east along the length of the basin. It shows the barge weighing machinery dock on the left, with what seems to be the canal dredger inside with the funnel down and a tarpaulin over the living cabin. Bourne Mill or Hack's Mill is in the distance and the hipped-roofed warehouse on the port island is on the right.

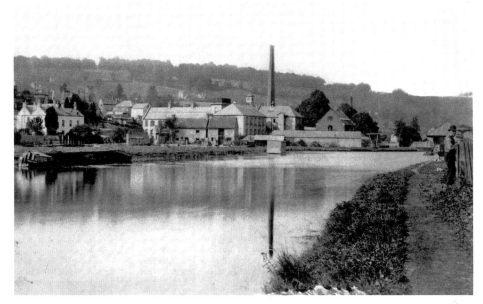

BRIMSCOMBE PORT, *c.* 1915. This view looking west also shows the large expanse of water which also went round behind the island on the left. The island was used for outdoor secure storage of goods in transit etc. An abandoned boat is moored by the island, and on the right, behind the man on the towpath, was the barge weighing machinery for checking cargo loads on boats so that the appropriate tolls could be levied. The large Brimscombe Upper Mill dominates the centre of the picture and in front of it are the lengthman's cottage and the salt store.

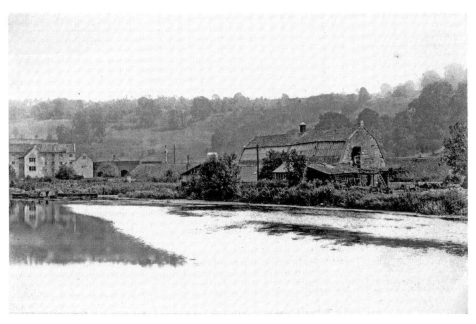

BRIMSCOMBE PORT, *c.* 1920. This was the eastern end of the port and shows the warehouse on the island. The railway runs behind the warehouse and then behind Bourne Mill on the left.

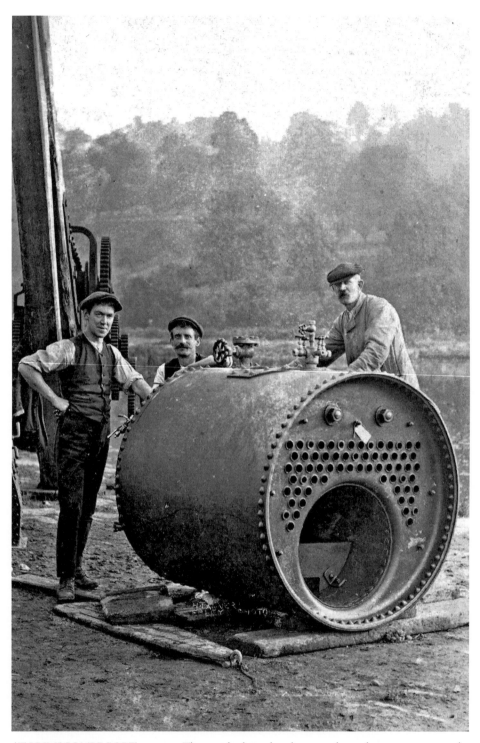

AT BRIMSCOMBE PORT, *c.* 1930. The port had two hand-operated wooden cranes, one on the west wharf and the other on the north wharf close to the headquarters building, which has been used to unload this steam boiler.

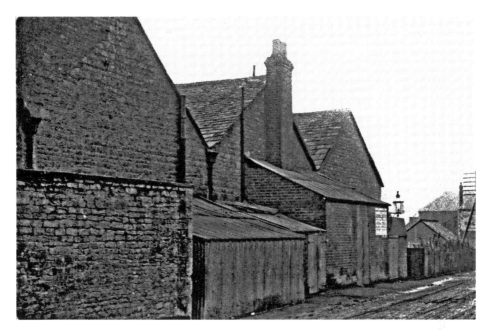

COMPANY HEADQUARTERS AT BRIMSCOMBE PORT, *c.* 1905. This was the back and road side of this very large building, which incorporated the headquarters, a warehouse and the agent's house. It was taken before any conversion work to the polytechnic was carried out.

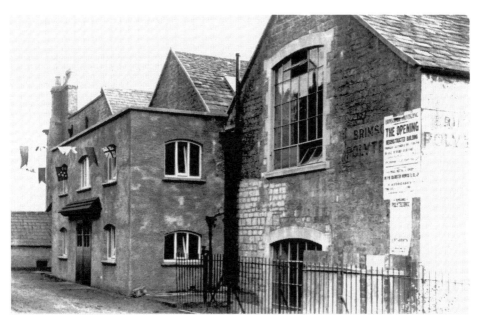

BRIMSCOMBE POLYTECHNIC, 1911. The conversion work has taken place and a brand-new entrance has been built on the edge of the road. The official opening was on 5 October 1911. A poster to that effect is visible on the corner of the building, and the entrance is decorated with flags and bunting.

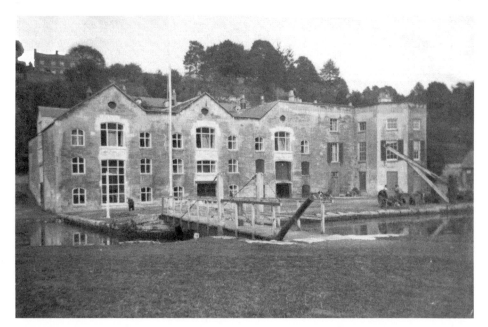

BRIMSCOMBE POLYTECHNIC, 1911. This shows the front of the building after conversion and improvements for use as the polytechnic. Note the swing bridge across the canal entrance into the basin and the steam boilers near the crane, probably for Abdela & Mitchell at Hope Mill, showing that there was still trade using the canal.

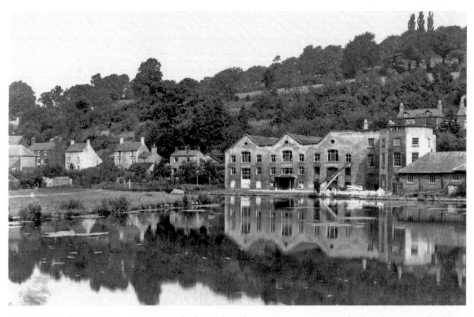

BRIMSCOMBE PORT, c. 1920. With the polytechnic now occupying the headquarters building the scene is otherwise unchanged apart from an almost complete lack of activity in the large basin. By the crane and the low shed used by the maintenance department there is a pile of stone, a lock gate and a balance beam.

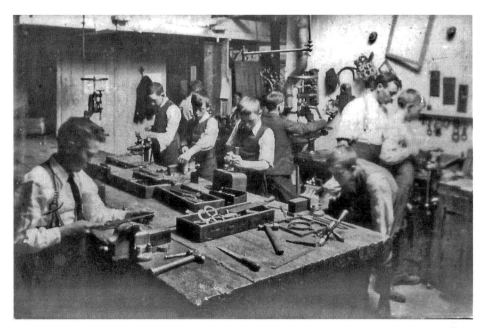

INSIDE THE POLYTECHNIC, 1912. Male pupils at work in the metalwork department.

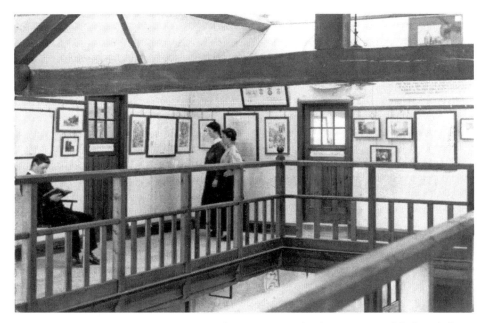

INSIDE THE POLYTECHNIC, c. 1915. This view is inside the open central hall and shows students on the balcony. The doors lead to the art department and the men's common room. Both of these views show interesting aspects of the inside of the old headquarters building.

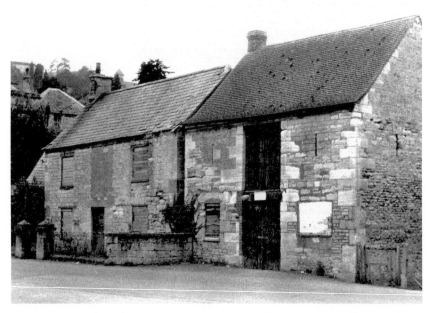

AT BRIMSCOMBE PORT, *c.* 1950. Although boarded up and not in use, both of these buildings have survived on the west wharf. On the left was the cottage of the lengthsman for this section of the canal, and on the right was the salt store.

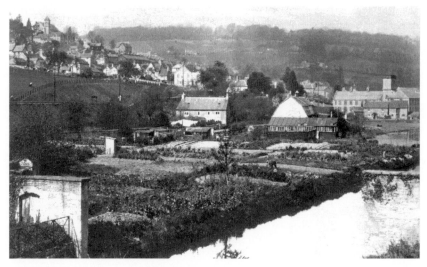

VIEW WESTWARDS FROM BOURNE LOCK BRIDGE, 1925. Looking back into the port. In the centre the warehouse was on the island. The gardens across the centre are where the water course came around from behind the island, showing that the basin has already been filled in here.

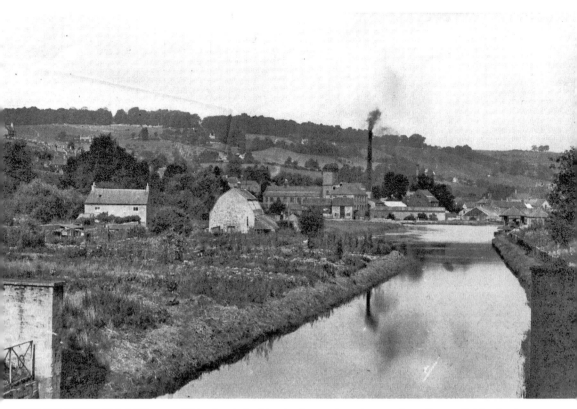

BELOW BOURNE LOCK, 1912. This view is looking back west into the port from Bourne Bridge Lock.

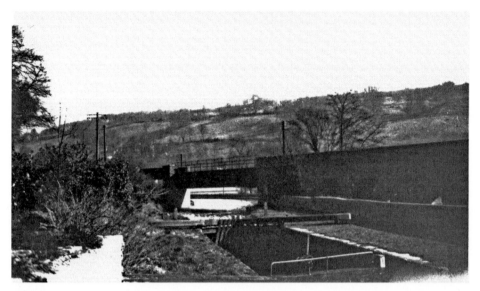

BOURNE LOCK, *c.* 1930. this view looks east and shows the only lock on the canal that had hybrid dimensions, being long enough for River Thames traffic but also wide enough for Severn trows. The reason for this was that the Bourne Dry Docks were just around the corner on the left, beyond the metal girder railway bridge over the canal.

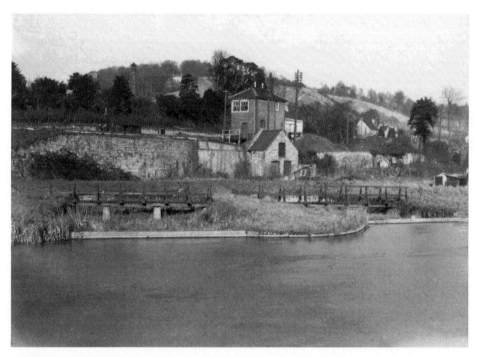

BOURNE DRY DOCKS, 1948. The two docks can be seen with wooden footbridges across their entrances. They were built from stone by the Canal Company in the late 1700s, for the building and maintenance of the company's carrying boats. All the work was out in the open and the docks could be emptied down into the River Frome.

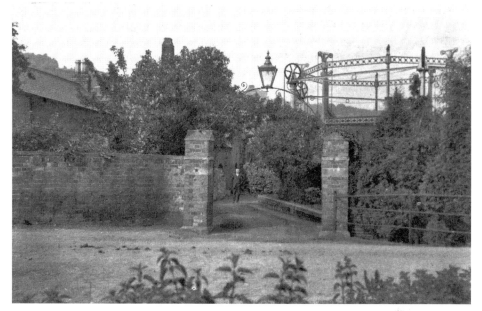

BRIMSCOMBE GASWORKS, *c.* 1920. This was just beyond the dry docks but close on the towpath side. The canal runs behind the retort house on the left. Coal was delivered by barge and carried direct into the works across the towpath.

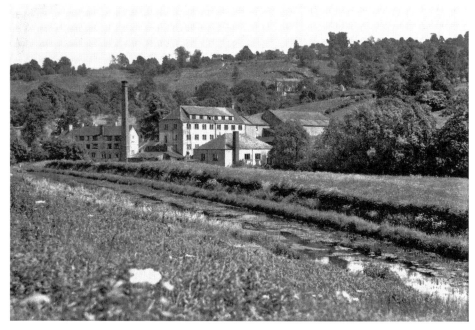

BETWEEN BEALE'S LOCK AND ST MARY'S LOCK, 1948. St Mary's Mill is in the centre seen across the canal pound. This pound was always kept well maintained so that the water held there could be used for the steam banker engines based at Brimscombe station. These extra engines were used to help push trains climbing the bank up from here to Sapperton Tunnel.

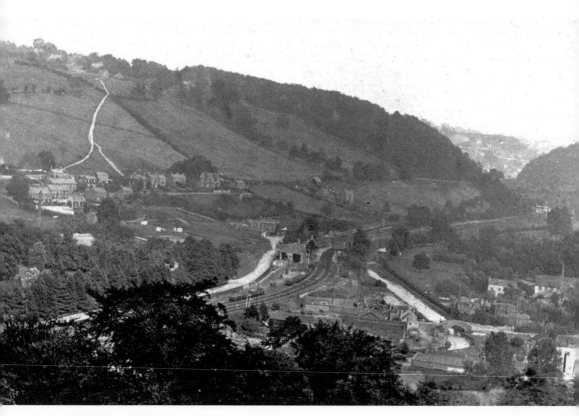

THE VIEW EAST UP THE VALLEY, 1900. This is from high up on the south side of the valley looking across the canal and Brimscombe station. Bourne Bridge and the gasworks can be seen in the right foreground, with the canal going straight up to Beale's Lock. Brimscombe Station is in the centre and the picture shows how the river, canal, road and railway all crowded into the relatively flat valley bottom.

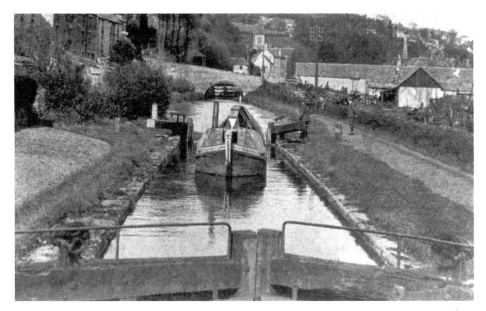

ILES'S LOCK, *c.* 1905. A good working picture of Smart's barge, *Flora*, working empty back down the canal. Iles's lock was also known as Grist Mill Lock. The locks in the valley are now closer together as the canal starts to climb up through the Golden Valley to the tunnel. The building at top-left was a butcher's slaughter house which drained either into the canal or underneath the canal and into the river.

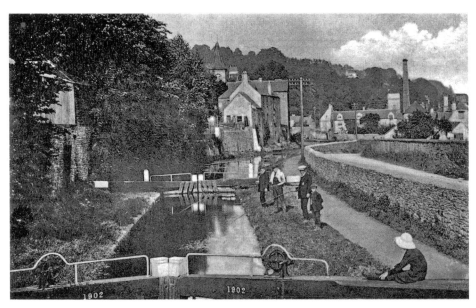

BALLINGER'S LOCK, 1913. A lovely peaceful scene on a summer afternoon with men and boys fishing in the lock chamber. The lock is in good condition, with the bottom gates, dated 1902, installed during the restoration of the lock by Gloucestershire County Council. In the centre-distance on the left is Chalford Police Station and on the right are Chalford Wharf and the tall chimney of Bliss Mills. The cottages behind the round house were demolished in the 1930s.

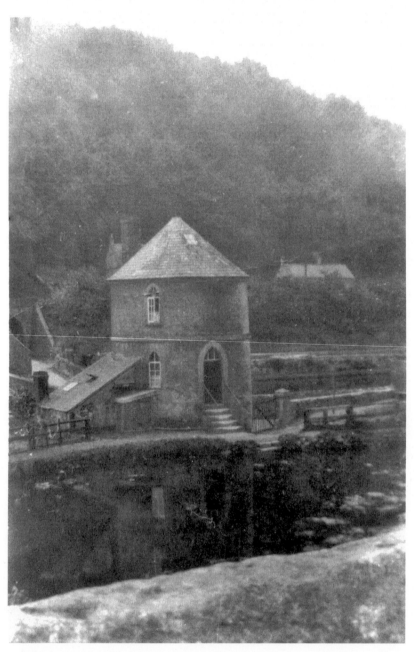

CHALFORD ROUND HOUSE, c. 1925. This is the first of five three-storey round houses built along the canal for lengthsmen to live in and operate from. The view is taken from the main road, by Chalford Chapel. On the left-centre is the railway bridge under the lines for the road up Hyde Hill to Minchinhampton. Chalford Wharf area is to the right of the round house and a wooden fence protects the water overspill weir here. Note also the entrance pillars and gates into the wharf by the side of the round house.

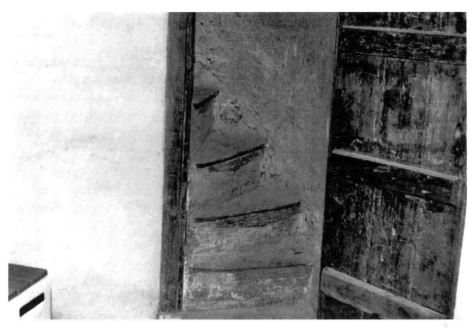

INSIDE CHALFORD ROUND HOUSE, 1979. The next three pictures were taken inside the round house when it was still in almost its original condition. This is the staircase from the first floor going up to the second floor and built into the wall itself.

INSIDE CHALFORD ROUND HOUSE, 1979. This was the top of the ladder access up into the attic room in the conical roof. Note the roof timbers and the half door that shuts across the ladder access for safety.

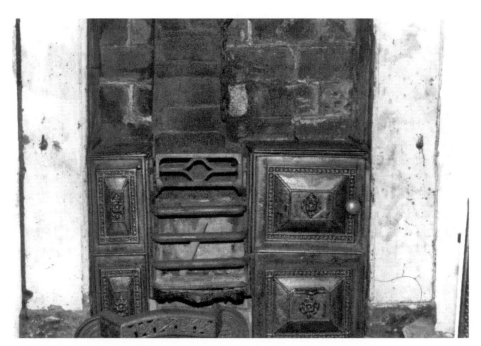

INSIDE CHALFORD ROUND HOUSE, 1979. The cast-iron cooking range with oven was built into the thickness of the wall, which also took the chimney flue. The spiral stone steps up to the second floor were also built into this thick wall and the access door to these steps was just to the right of this fireplace.

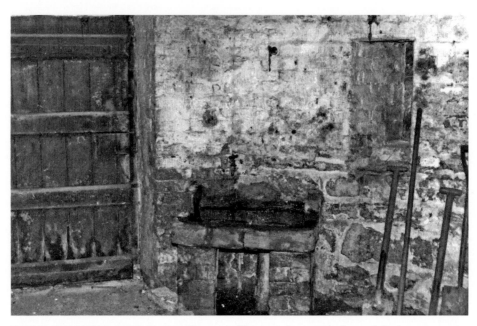

INSIDE CHALFORD ROUND HOUSE, 1979. This was the outside door of the basement area, where the lengthsman kept his tools needed to do his job. Note the stone sink and tap against the wall.

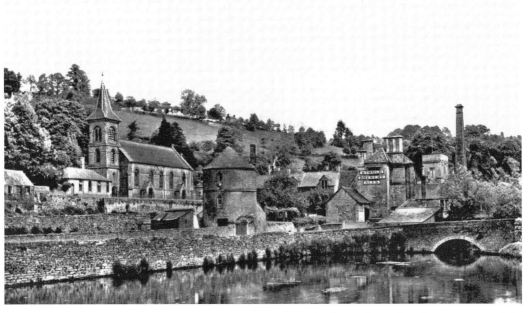

NEAR CHALFORD WHARF, *c.* 1930. This view was across Belvedere Mill Pond on the River Frome. The canal was higher than the river and runs across from left to right between the round house and Chalford Chapel.

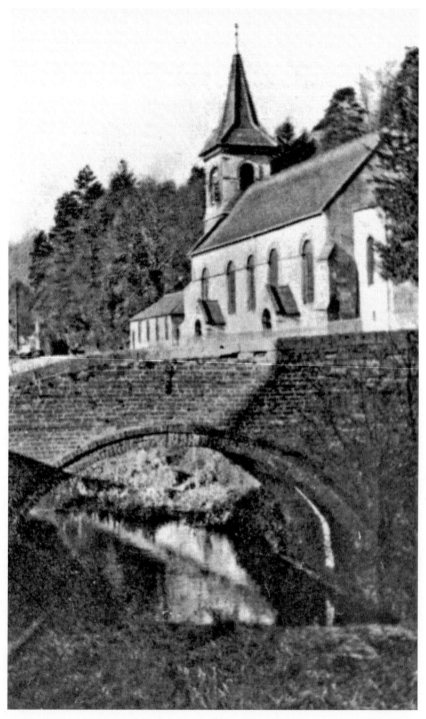

CHALFORD CHAPEL BRIDGE, 1950. When these bridges were built they were mostly hump-backed, but after the turnpike road was built through the valley the bridge parapets had to be sloped up to it, and it is still possible to see this added stonework up on the right after more than 150 years have passed.

BELOW CHALFORD CHAPEL BRIDGE, 1955. The bridge was over the tail of Chalford Chapel Lock. In the early 1960s it was demolished for a road-widening scheme, which resulted in most of the canal bed being filled in apart from a small channel for storm water.

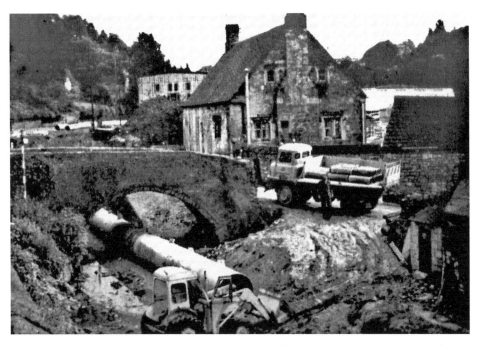

CHALFORD CHAPEL BRIDGE AND LOCK, 1964. This shows the work in progress for the road widening project. A pipe of large diameter was inserted through the lock chamber and under the arch of the bridge for storm water etc. The lock chamber and bridge were then collapsed on to the pipe and the whole feature disappeared.

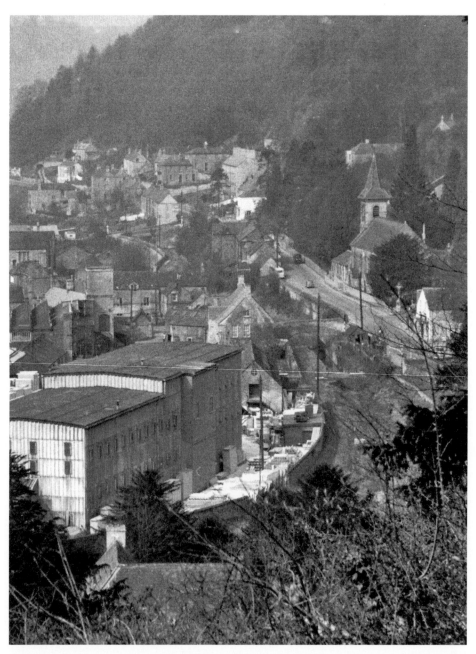

BLISS MILL SITE, *c.* 1950. On the right it is evident that the canal was in a very bad state. The view looking down the canal is dominated by the Bliss Mill complex on the left. These large buildings were erected by Fibrecrete. Up on the skyline the angled tree line gives a good indication of the steepness of the valley at this point.

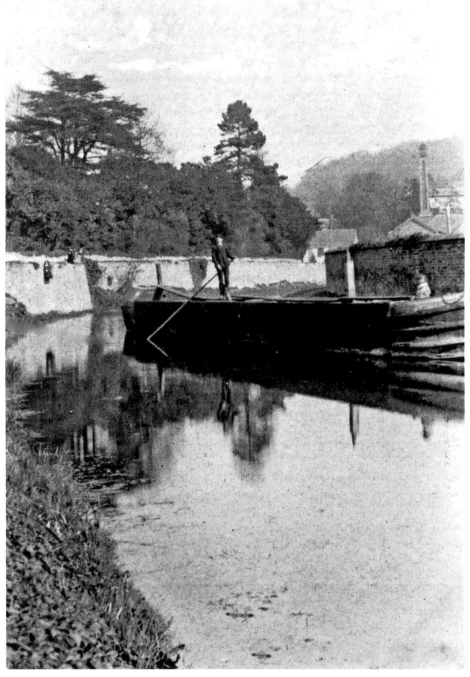

ABOVE CHALFORD CHAPEL LOCK, *c.* 1915. This view looks east up the canal as it curves round past Bliss Mill towards Bell Lock. There was a small wharf on the right where coal, mainly, was unloaded directly across the towpath into the mill, and this barge was probably part of that process. The main road through the valley is up behind the retaining wall on the left.

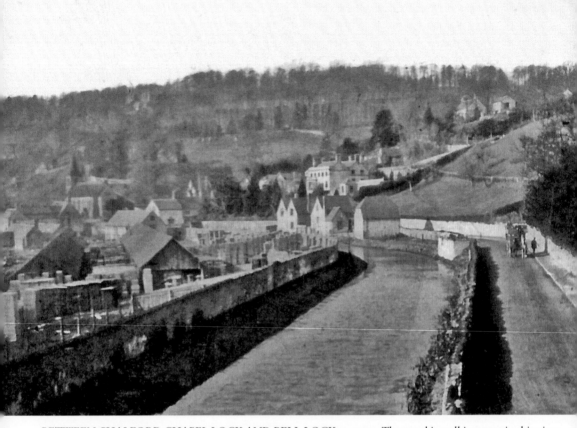

BETWEEN CHALFORD CHAPEL LOCK AND BELL LOCK, *c.* 1900. The canal is well in water in this view looking west. Note the horse bus on the road near to the council roadstone layby. Most of the canal here disappeared with the 1960s road widening scheme.

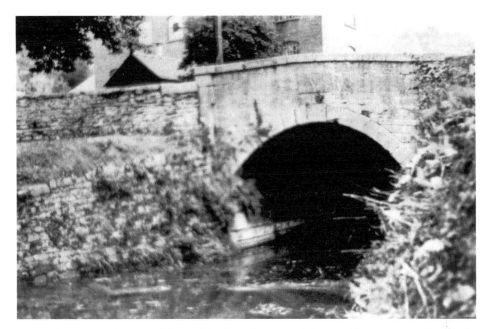

BELL LOCK BRIDGE, 1932. The road in the valley crossed the canal here to go up Cowcombe Hill. When the bridge was built it was at right angles to the canal and was suitable for horse-drawn traffic, but later, as motorised traffic came on the roads, it was most unsuitable, especially at the bottom of the hill. In 1933 the bridge was realigned to smooth out the sharp angle.

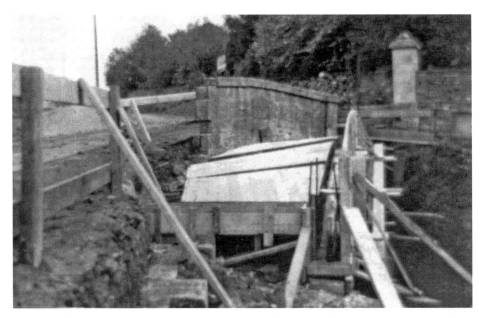

BELL LOCK BRIDGE, 1933. Realignment of the bridge was underway to take out the sharp corners. Wooden shuttering shows the alignment for the new stonework etc. The canal towpath also changed sides here, crossing from the right-hand side to the left going up the canal.

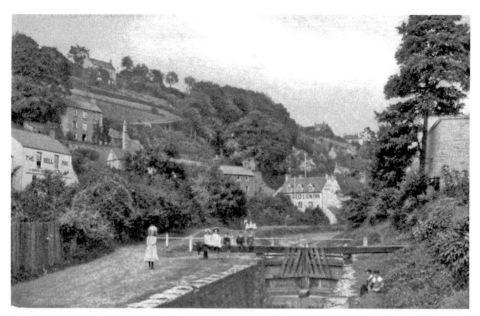

BELL LOCK, *c.* 1900. This view was taken from Bell Bridge looking east. The lock was named after the Bell Inn on the left, and it was a particularly deep lock lifting the canal by ten feet. Some local children have been posed on the balance beam, but there is little water in the canal as this was around the time of the restoration by the Gloucestershire County Council.

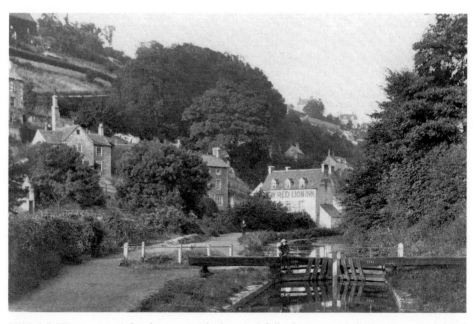

BELL LOCK, *c.* 1920. A lovely scene with the canal full of water, and the bottom gates, dated 1904 from the canal restoration. There would not have been much traffic here at this time, probably just an occasional barge up to the Daneway Basin but no further as traffic across the summit level stopped in 1912.

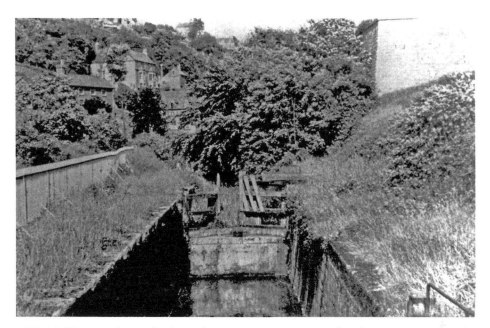

BELL LOCK, 1936. A very derelict and overgrown scene compared to the previous picture. The lock gates are broken. This was only three years after official abandonment and clearly shows how deterioration rapidly sets in once traffic and maintenance stops. Note the iron railings along the towpath that were erected in the early 1930s following a near fatal accident when someone fell into the deep lock chamber.

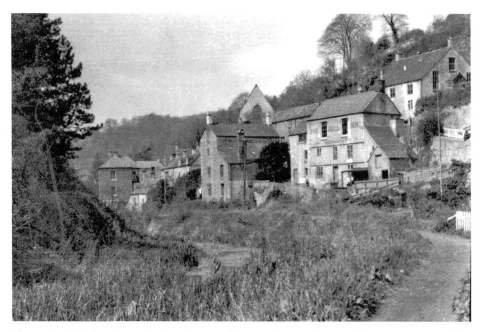

ABOVE BELL LOCK, 1937. There is very little water here; probably only storm water remains, using the canal bed as a run-off channel. The Bell Inn was demolished in the 1960s.

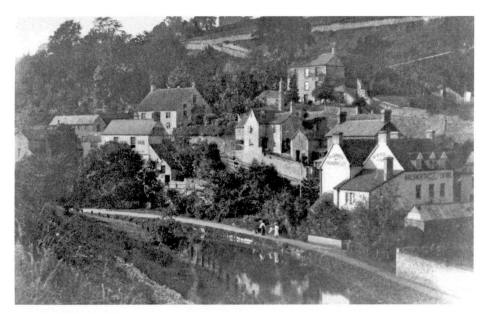

ABOVE BELL LOCK, *c.* 1910. The canal curves round towards Red Lion Lock, so named after the Red Lion public house, which can be seen here on the right. The Red Lion was rebuilt after a fire in 1888.

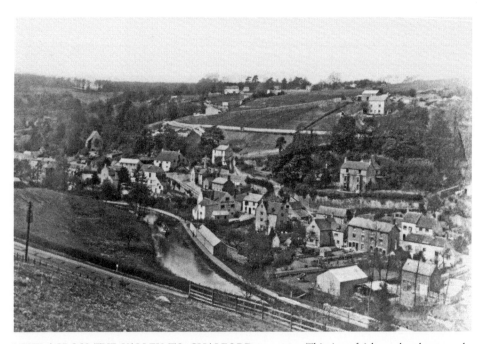

VIEW ACROSS THE VALLEY TO CHALFORD, *c.* 1885. This is a fairly early photograph, showing the canal below Red Lion Lock. As yet there is no railway station on the ground to the left-centre. A barge is working down the canal on the curve. There was a small boatyard near the large shed in the right-foreground.

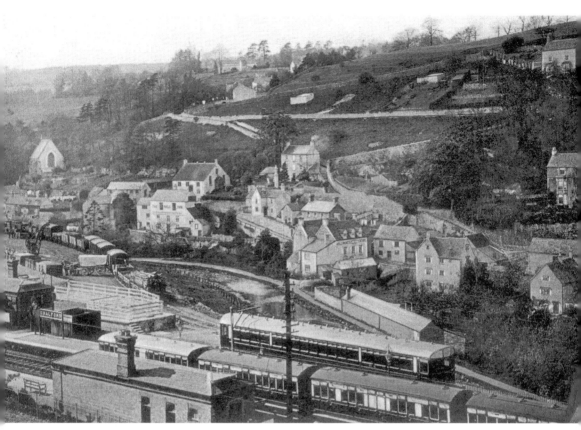

VIEW FROM ABOVE CHALFORD STATION, *c.* 1905. This view compares directly with the previous picture and the railway station and goods yard are now visible, having been opened in 1897. A long rail motor is in the siding alongside the train in the station on the up line and there is plenty of activity in the goods yard at left-centre.

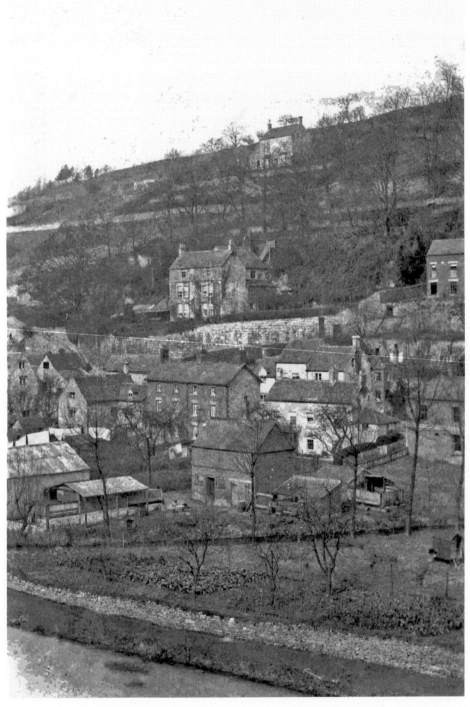

BELOW RED LION LOCK, *c.* 1900. The canal runs across the foreground, with the small boatyard in the sheds on the left. The Spion Kop Studio at Chalford dates the photograph to the period of the Boer War.

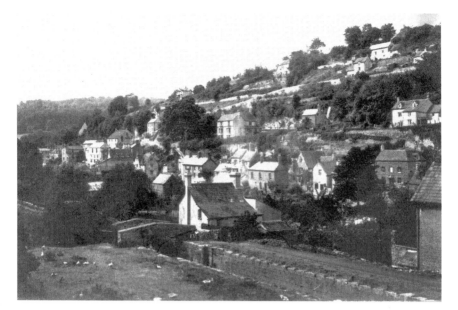

RED LION LOCK, *c.* 1935. This lock was also known as Clowes's Lock. The lock chamber is dated 1784 and the beautiful dressed-stone bridge dates from the following year. It is thought that the canal engineer, Josiah Clowes, possibly designed the bridge as a monument to himself as there is no other comparable bridge anywhere on this canal. By 1935 the canal has been abandoned a few years and the lock gates are gone.

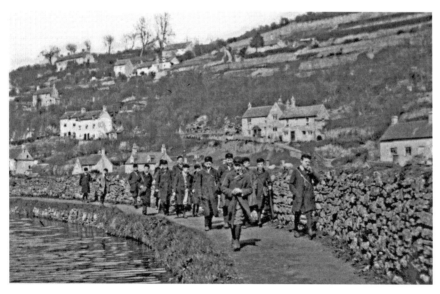

ABOVE RED LION OR CLOWES'S LOCK, *c.* 1910. These school boys are possibly from either Wycliffe College or Marling School in Stroud and are on their regular Sunday afternoon walk. The sharp curve in the canal at this point was because the canal had to avoid the Seville's Mill pond, down below the towpath boundary wall. The space available in this very narrow valley is such that when the railway line was built here it had to be held up on to the side of the unstable valley slope with a half-width viaduct.

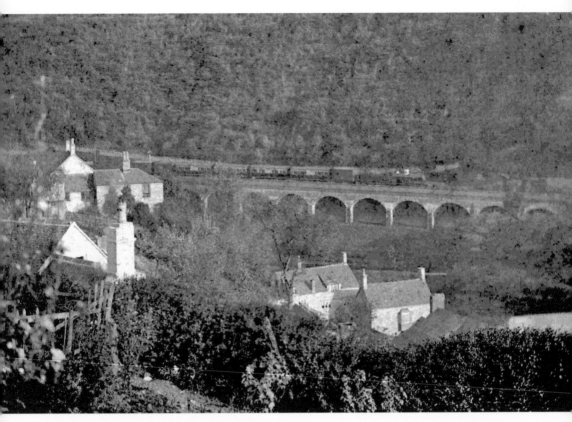

RAILWAY HALF-VIADUCT BELOW COWCOMBE HILL, *c.* 1895. A train is coming down the line on the half-viaduct next to the section called the narrows. The canal is deep down in front of the viaduct.

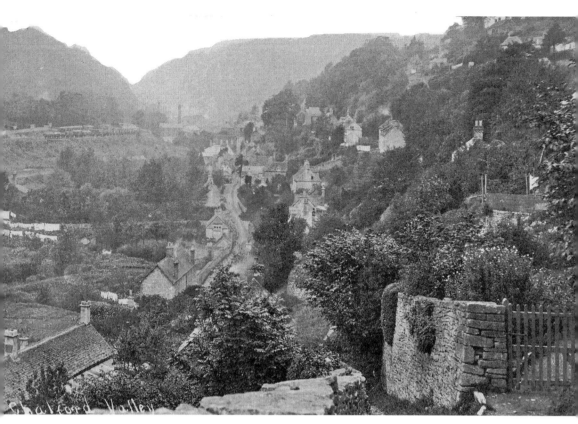

CHALFORD VALLEY, *c.* 1895. Looking west back down the valley, all the different means of transport through this narrow valley can be seen. The River Frome, the canal and the road are all in the valley bottom, but the railway, which was the last to come through here, had to use the valley side, seen up on the left background.

BELOW VALLEY LOCK, *c.* 1915, looking east up the canal. A wooden bridge was built across the tail of Valley Lock. It became unsafe and was replaced in the mid-1950s. On the left is Valley Mill, also known as Tyler's Mill, which was demolished in the 1920s. The stone sold to build a bungalow on the hill to the north. On the right is the Clothier's Arms.

ABOVE VALLEY LOCK, 1911. A barge is moored in the canal. It has probably brought coal up to Chalford Waterworks, which is off to the right.

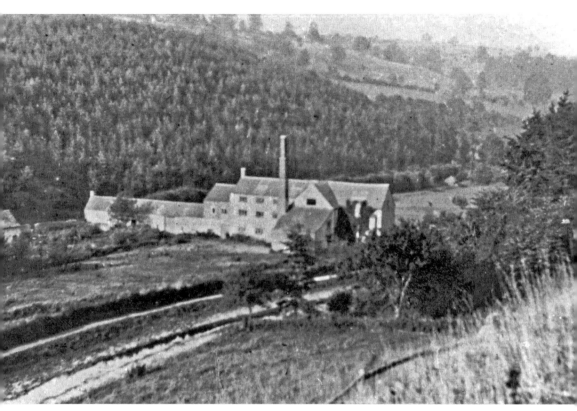

BY ASHMEAD'S MILL, *c.* 1885. The large complex of Ashmead's Mill sits in the centre, with the canal across from left-foreground. The canal is empty of water, as this was just prior to the attempted restoration by a trust in the 1890s, when the canal had got into bad condition. Coal was brought up to this mill and would have been unloaded direct across the towpath and the small River Frome into the mill. The centre part of the mill was converted to a house in 1903 and the rest of the building was demolished and the stone sold for building.

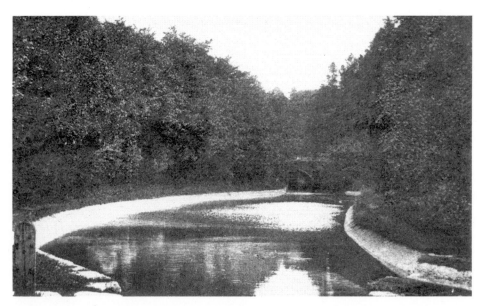

ABOVE BOLTING LOCK, *c.* 1900. It was also known as Baker's Mill Lower Lock. This pound up to Baker's Mill Upper Lock beyond the bridge was lined with concrete by the trust to stop bad water leakage down into the River Frome. It became known locally as the 'conk' and was a renowned swimming place.

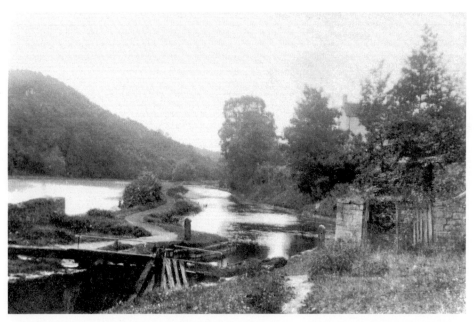

BAKER'S MILL UPPER LOCK AND RESERVOIR, *c.* 1920. This lock is in the left-foreground. Coal was brought up to this lock and unloaded across into Baker's Mill and also taken up to Oakridge Mill. Above the lock gates on the right was a small coal yard. The towpath twists between the canal on the right and the all-important canal reservoir on the left.

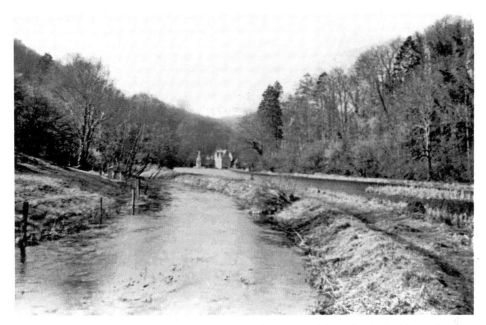

ABOVE BAKER'S MILL, 1976. Looking west down the canal and the valley the buildings of Baker's Mill are in the centre. The canal and the reservoir over to the right are both full to overflowing due to the rain and floods that followed the 1976 drought. The company purchased Puck Mill further up the canal in order to put it out of use so that the water could then be used to fill this reservoir.

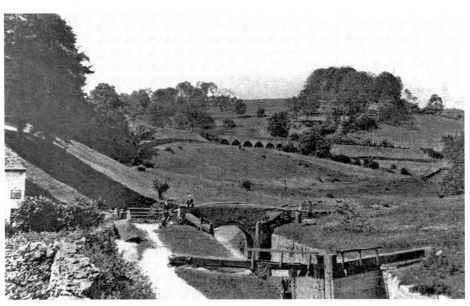

PUCK MILL UPPER LOCK, c. 1895. A derelict scene. There is no water and the gates are in a bad state. Happily this was all about to be restored by the Trust. The Oak, on the left, could only be reached by canal, towpath or a footpath down from Frampton Mansell. It was a true canalside public house for canal and barge people. The towpath changed sides here, over from the right to the left, as seen in this photograph looking down the canal.

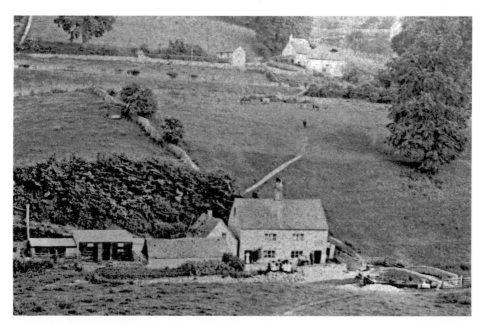

BY PUCK MILL UPPER LOCK, *c.* 1905. This shows The Oak in its isolated location alongside the lock. The lock chamber is out of sight, with only the bottom gates showing above the bridge.

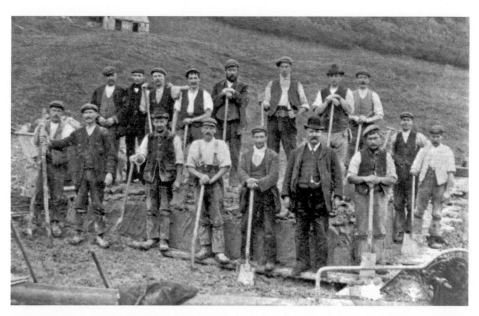

RESTORATION AT PUCK MILL UPPER LOCK, 1907. After the failure of the Trust to restore the canal, the Gloucestershire County Council took over the restoration task. Here the workforce is lined up for the photograph and they all have the tools of their trades with them. They are standing alongside the lock chamber on a pile of clay that will be used for puddling the canal bed. The clay was needed in such large quantities here that it was moved about using tubs that ran on rails, and it may possibly have been brought over in barges from the Furzen Leaze claypit on the other side of the tunnel.

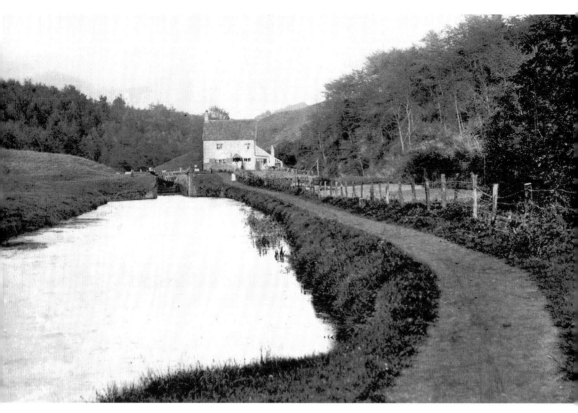

BELOW WHITEHALL LOWER LOCK, 1909. This was the short pound between Puck Mill Upper Lock and Whitehall Lower Lock. The lock can be seen in the distance with the lengthsman's cottage alongside it. Everything is now in good condition after the restoration and there is plenty of water and a good, well-used towpath.

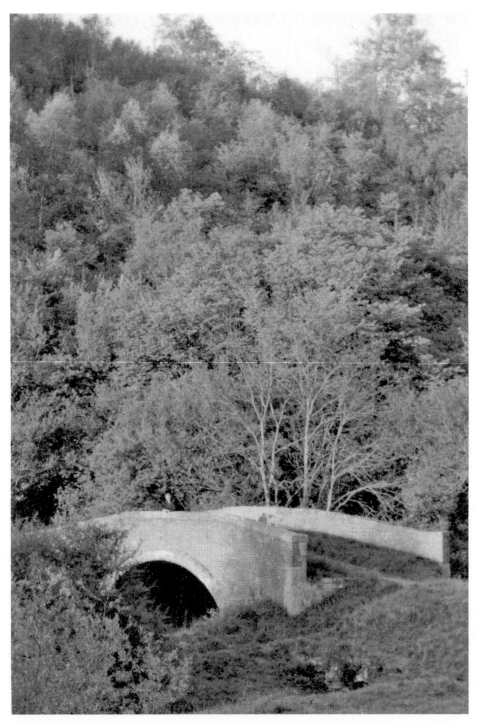

WHITEHALL BRIDGE, c. 1950. A good picture of the 'Golden Valley'. The bridge carried various tracks that converged here through the woods mostly down from Frampton Mansell and then up through Trillis Woods towards Far Oakridge. This bridge is in a significant location and denotes the point from which the eastern section of the canal was abandoned in 1927.

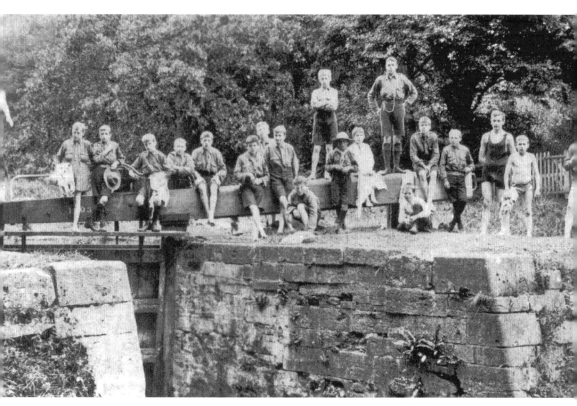

BATHURST MEADOW LOCK, *c.* 1920. These Woodchester boy scouts were on an outing to the flight of locks here. Some are resting on the balance beam and others have been swimming in the lock chamber. The group probably made their journey to here by rail to Chalford and then walked. Note the 1903 date on the balance beam, showing when this lock was restored.

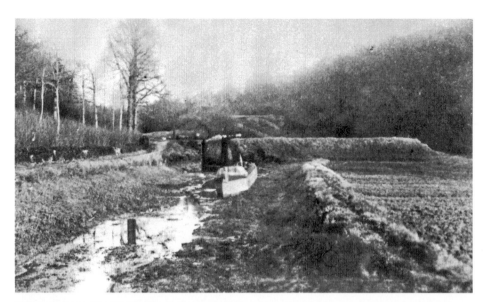

BELOW SICCARIDGE WOOD LOWER LOCK, 1896. The locks are very close together here as the canal climbs steeply up to the summit level beyond Daneway Upper Lock. This was at the time of the attempted Trust restoration, thus the canal has no water and a barge has been marooned in the pound above Bathurst Meadow Lock. Shown very clearly on the picture are the side pounds on the right of each lock in this flight. It was hoped that these would give extra water capacity to operate the locks, as the original pounds between the locks were inadequate for sustained use.

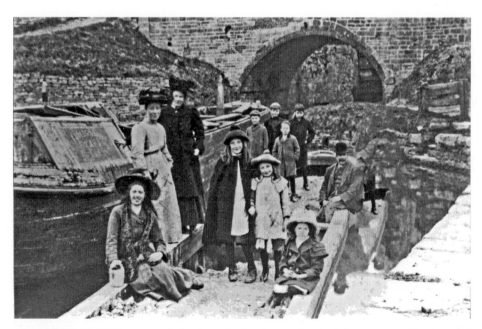

AT DANEWAY BASIN, c. 1910. A family outing on the canal with the barge moored in the canal by Daneway Bridge. Through the arch is the Daneway Upper Lock onto the summit level. The other barge lined up with the bridge is one of James Smart's from Chalford possibly ready to proceed on up the canal.

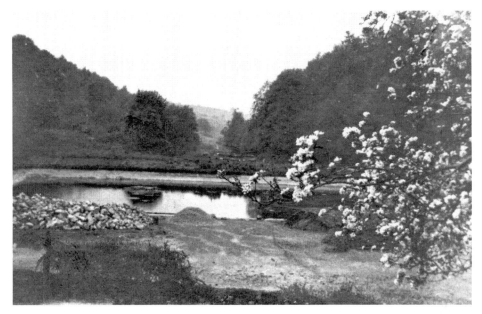

DANEWAY BASIN, 1911. This view, taken from the causeway which crosses the Daneway Bridge, shows an interesting working scene, with piles of stone on the wharf on the left and coals on the right behind the blossom. The flight of locks goes down the canal and their route is shown by the gap in the trees in the background.

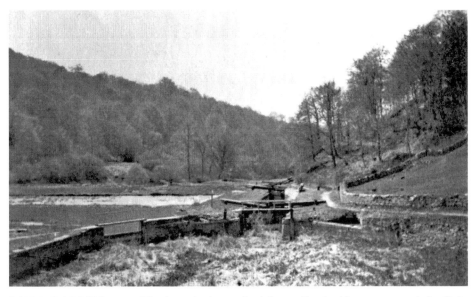

DANEWAY BASIN, 1917. The large basin on the left was lined with concrete and the flight of locks goes down the canal. However, here there is no water and the canal is unusable and becoming derelict.

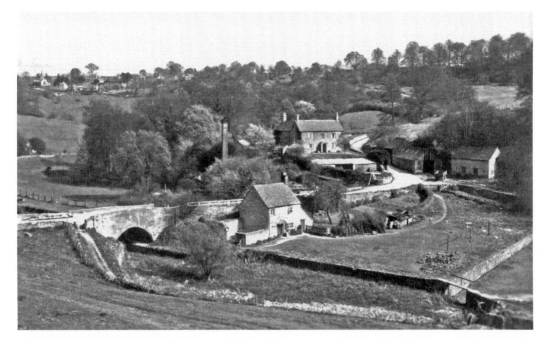

VIEW ACROSS DANEWAY WHARF, *c.* 1930. The whole wharf complex can be seen here because there is little tree growth. The canal has now been abandoned for a few years and only storm water uses the channel. The sawmill chimney emerges from the trees behind the wharf house, but the machinery was cleared out in 1927 and then taken up to the Midlands by Phil Mills using one of Smart's barges.

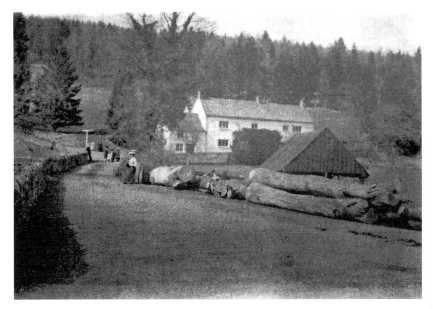

AT DANEWAY, *c.* 1905. A good Edwardian scene, with tree trunks lined up on the side of the road ready for the sawmill, which is down to the right. The mill was originally water powered but later converted to steam power due to the irregular water supply from the River Frome. The Bricklayer's Arms public house is in the background.

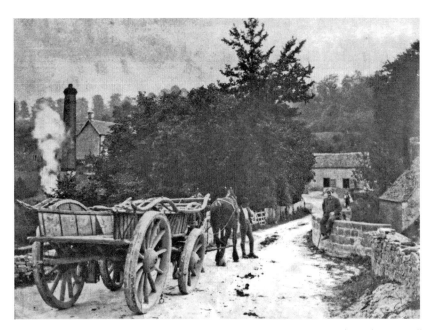

AT DANEWAY, *c.* 1910. A busy scene looking across Daneway Bridge. The sawmill is in operation and the two-horse wagon about to cross the bridge has probably come down to take away sawn timber. The lack of commercial traffic on the canal soon after this date hastened the closure of the sawmill, as it was fairly dependent on canal transport for heavy timber loads both in and out.

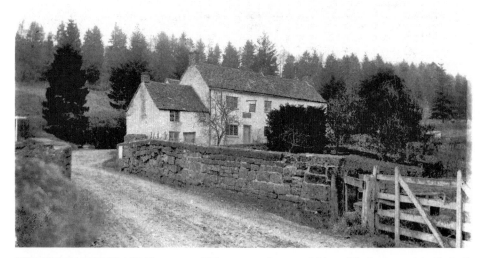

THE BRICKLAYER'S ARMS, *c.* 1900. This was another canalside public house, originally built as a hostel in 1784 for the workers in the tunnel during the six-year period of construction. Daneway Bridge was also known as Causeway Bridge and this is where the towpath changes from the north side of the canal to the south side. Here it goes off to the right through the small gate and it remains on the south side for the rest of the canal route through to Inglesham, where it joins the River Thames. The pub was later renamed the Daneway Inn.

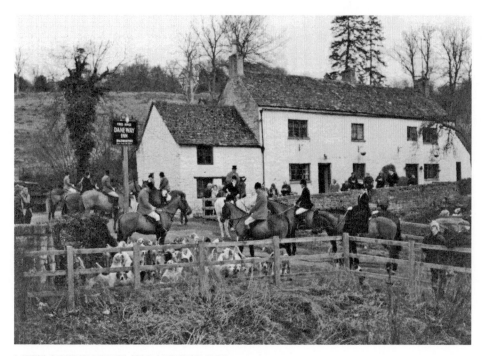

MEET OF THE HUNT AT DANEWAY INN *c.* 1960.

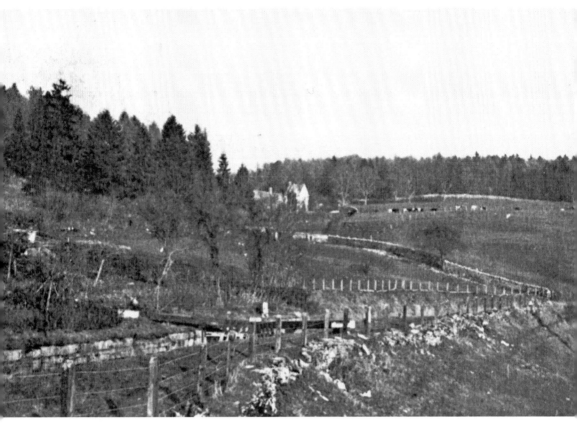

DANEWAY BRIDGE LOCK, 1916. Also known as the Summit Lock. At the summit the water level is 362 feet above OD and the canal has risen up 241 feet from the Wallbridge Junction. Daneway House is in the centre and on the left are the gardens of the public house.

ABOVE DANEWAY BRIDGE OR SUMMIT LOCK, 1936. The canal has been abandoned for ten years but no traffic has passed this way for twenty-four years. As such, the canal bed is full of reeds but the trees have not yet encroached upon it. In the background is the higher ground where Sapperton village lies and where the canal curves round to the tunnel, which passes through this high ground.

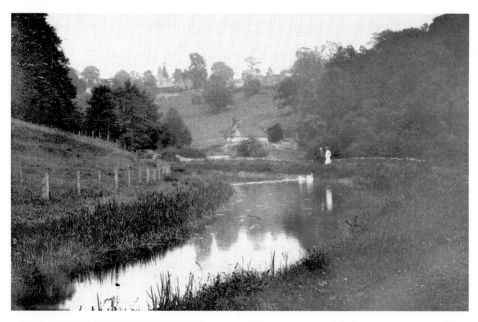

APPROACHING SAPPERTON TUNNEL, c. 1910. What a contrast with the previous picture! Here there is plenty of water in the summit level. In the centre is the lengthsman's cottage at the tunnel entrance. In Edwardian times it was a pleasant afternoon walk for many and it remains so today.

MR AND MRS GLEED. Mr. George Gleed who worked for Smart's at Chalford took the last commercial load of 20 tons of roadstone through the tunnel in May 1911 to Lechlade and returned with a load of timber. Previous to this, a commercial load of 24 tons of grain passed over the summit in April 1911. Local stories abound of other boats crossing the summit level and the tunnel but not commercially. In 1914 a barge is reputed to have come from Swindon to Ashmeads Mill near Chalford to load furniture to take back to Swindon. Natural water levels might have been sufficient in a wet winter period for a light load but no water pumping took place at Thames Head Pumping Station in to the summit level as that had stopped a few years prior to this date.

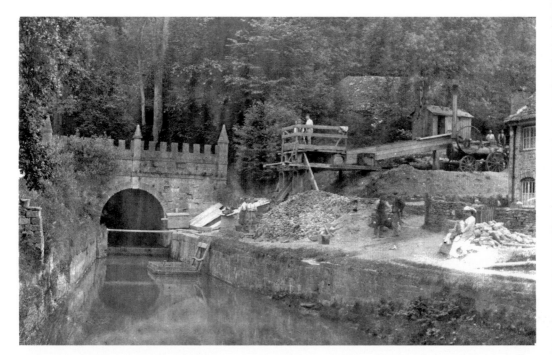

SAPPERTON TUNNEL RESTORATION, *c.* 1905. Full-scale restoration became necessary after the Trust failed to complete the task and the Gloucestershire County Council took over their responsibilities. They eventually restored the canal to full working order but within a few years traffic ceased across the summit level. In this view work was in progress with materials for use inside the tunnel and a stationary steam engine was set up to drive a clay chopper to reduce clay lumps to smaller pieces suitable for puddling work. This material was then loaded onto the small flat-bottomed punt and taken inside the tunnel. Stonework repairs were also needed and the lady on the right is sitting on the stone pile.

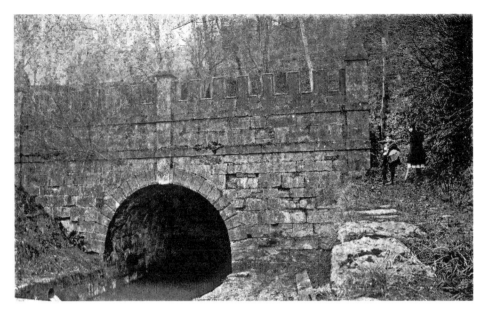

SAPPERTON TUNNEL ENTRANCE, *c.* 1900. The imposing gothic-style façade of the tunnel portal can be seen. No vandalism has taken place because Mr Whiting, the lengthsman, was living in the cottage here and kept watch. The children on the right are probably from his family.

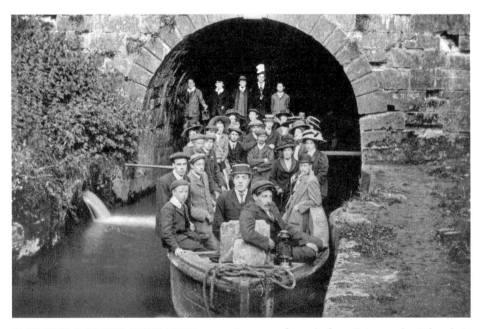

SAPPERTON TUNNEL ENTRANCE, 1911. A group of people from Brimscombe Polytechnic take a trip into the tunnel. They are all well dressed for the journey and have two poles to push themselves along against the sides of the tunnel. They also have oil lamps to use in the dark. Note the inflow of water on the left, which came down the valley from the outflow of Dorvel Mill and was a valuable feeder here. This water was also used as the water for the lengthsman's cottage as it was inherently cleaner than that in the canal.

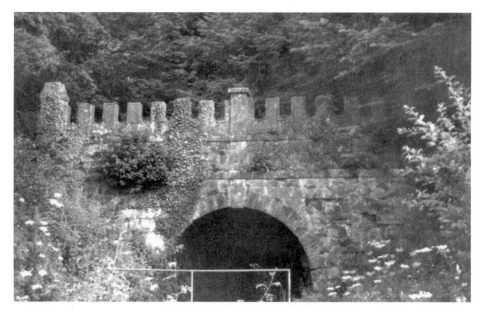

SAPPERTON TUNNEL ENTRANCE, c. 1950. The façade has started to suffer vandalism and the pinnacles have been pushed off into the canal bed. For many years some planks and a handrail spanned the entrance and it is said that it was possible to see daylight through the 2¼-mile long tunnel from one side of the entrance but not from the other side.

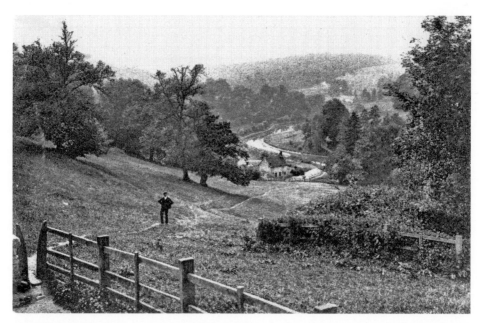

SAPPERTON VALLEY, c. 1905. In the distance down in the valley the canal summit level curved round before entering the tunnel by the lengthsman's cottage in the centre. This higher ground rises another 240 feet over the tunnel. This is a lovely clear view following some tree felling around 1900, but nowadays the whole view is lost.

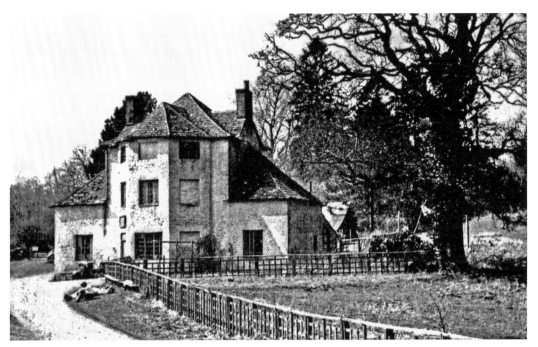

TUNNEL HOUSE, 1947. This shows the original building, as erected by the canal company as a hostel for the tunnel workers who were excavating the tunnel, for the six years it took to complete it. It was known as the New Inn, a beautifully proportioned Cotswold building. It is situated above the tunnel at the Coates End, in a very isolated location down a long track from the Tarlton Road.

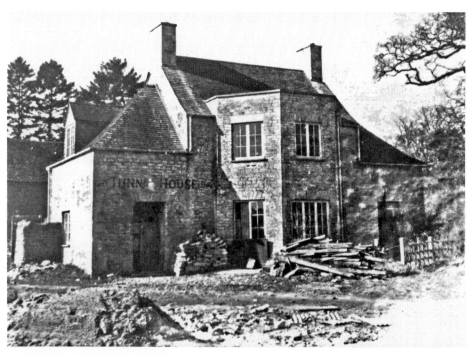

REBUILDING THE TUNNEL HOUSE, *c*. 1953. In 1952 a disastrous fire nearly destroyed the building. The rebuilding is shown here, nearly completed, with the yard full of materials. The original roofline and elevations were not fully recreated, and clay tiles were used on the roof in place of the Cotswold stone tiles. Compare this scene with the previous picture.

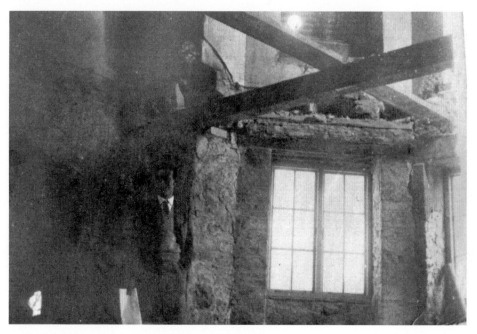

FIRE DAMAGE INSIDE THE TUNNEL HOUSE, 1952.

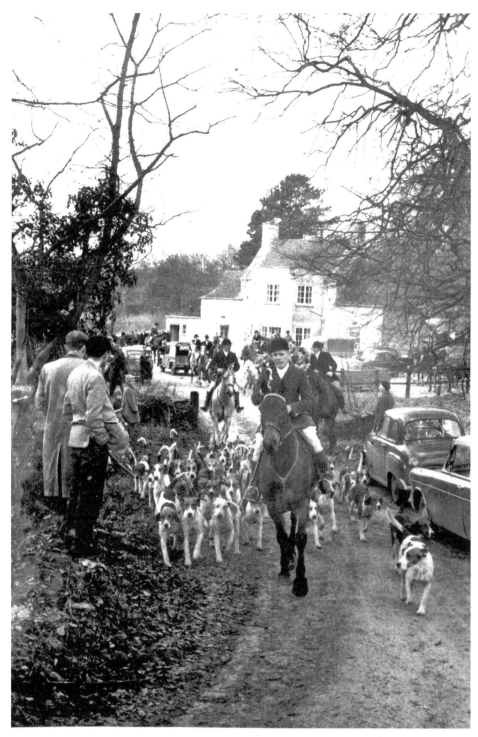

MEET OF THE VWH BATHURST HOUNDS AT TUNNEL HOUSE, *c. 1960.*

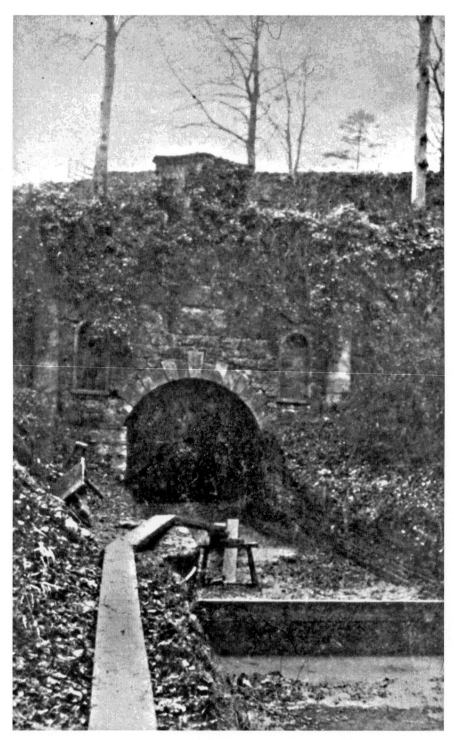

COATES TUNNEL ENTRANCE, 1896. Restoration work by the original trust is underway with boards for wheelbarrows and stop planks to prevent water from entering or leaving the tunnel while the work is going on.

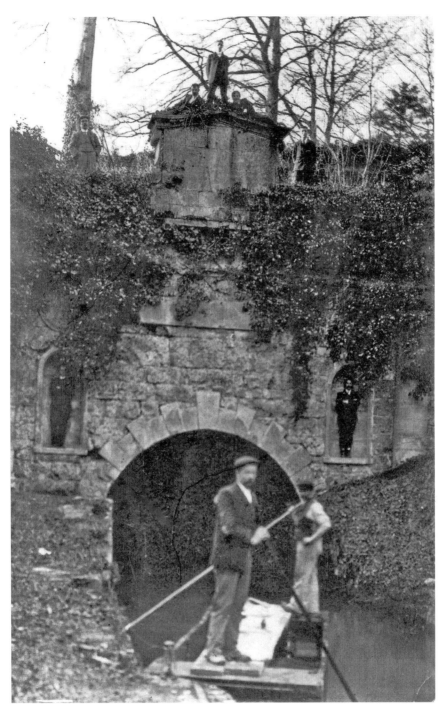

COATES TUNNEL ENTRANCE, *c.* 1910. A small maintenance punt is being used to go into the tunnel and check for problems. This punt was from the Daneway end and based at the lengthsman's cottage there. The Coates Tunnel entrance was a classical façade with a tablet at the top and niches and pillars on either side of the entrance, all neatly posed with visitors for the benefit of the photograph.

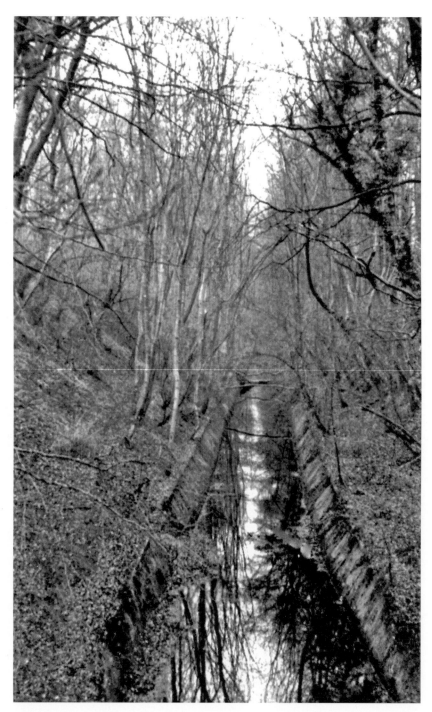

THE KING'S REACH, 1962. As the canal emerged from the tunnel it was in a deep cutting, called the King's Reach following the visit of King George III during the construction period. This view is looking south from above the tunnel entrance. This stretch was concreted in the early 1900s to stop severe water leakage and it still remains in good condition today.

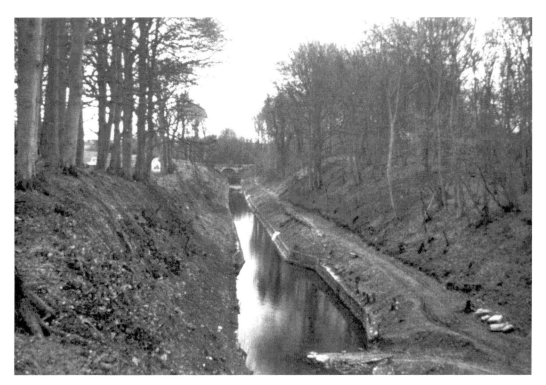

THE KING'S REACH, 1977. A similar view to the previous picture, but looking a good deal tidier and more workmanlike. The trees in the cutting right down to Tarlton Bridge were felled by the Bathurst Estate in the mid-1970s and that was followed by restoration by the Stroudwater, Thames & Severn Canal Trust volunteers. The tunnel portal was also restored a few years later. A small slipway was established that was used for machinery access at the time of restoration and was left in place for future boat access.

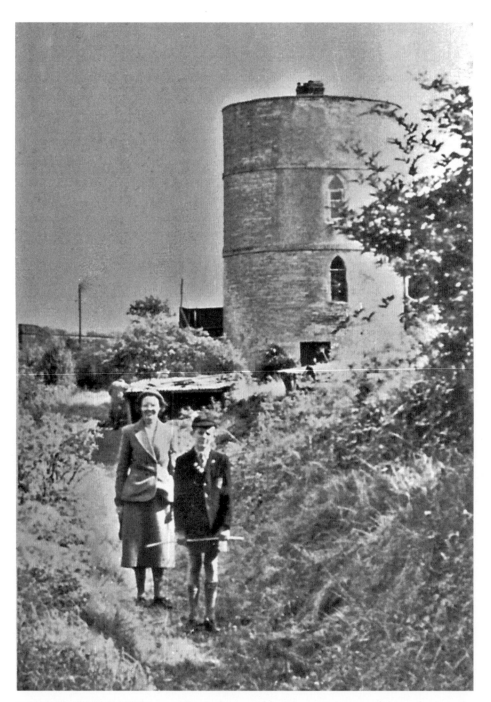

COATES ROUND HOUSE, 1954. This is the second lengthsman's cottage of this style along the canal, but access to it was only by the canal towpath. It was occupied for many years after the canal was abandoned in 1927 and here it still appears to be complete. As the years have passed it has become an empty shell.

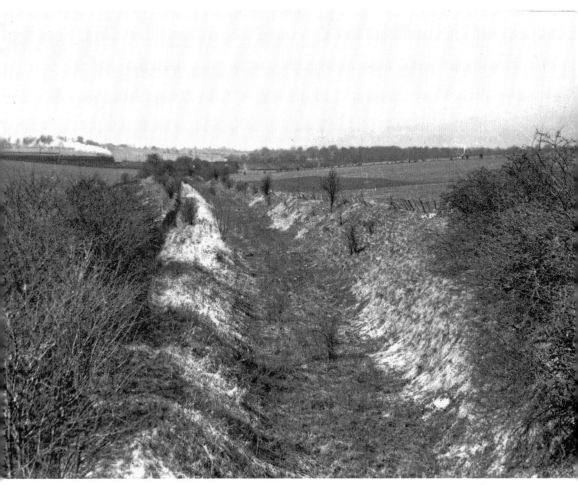

BEYOND SKEW RAILWAY BRIDGE, 1947. This was looking west back towards Skew Bridge. The canal profile is dry; a reflection of the original canal engineer Robert Whitworth's opinion that this was 'bad, rocky ground' and that it would always be difficult to make it hold water. A passenger train is coming up the line and is about to cross Skew Bridge. Hailey Woods are on the skyline in the centre.

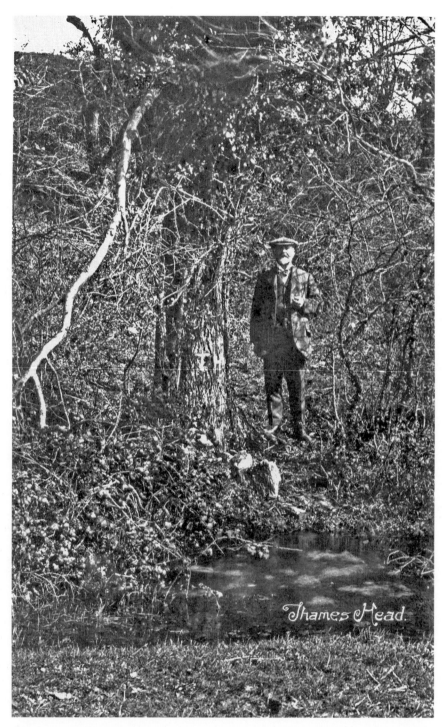

Thames Head.

AT THAMES HEAD SPRING, *c.* 1915. The true source of the River Thames is here in Trewsbury Mead, below the canal. The letters T. H. were carved into the trunk of the ash tree which grew behind the spring. Nowadays the spring only flows when there has been prolonged wet weather in winter time.

THAMES HEAD WHARF, 1977. These are the buildings at the wharf, and the track in the foreground comes down off the Fosse Way main road. One of the entrance pillars to the small wharf, canal and towpath is to the left-centre and the canal runs parallel and behind the buildings.

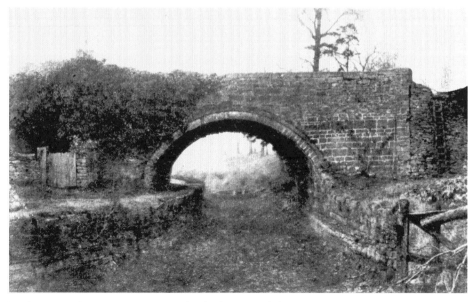

THAMES HEAD BRIDGE, 1896. This bridge carried the Fosse Way road over the canal and the Thames Head Wharf was on the left beyond it. The state of the canal is obvious here on the summit level and the Trust attempt at restoration is about to start. Note that a small boat lies abandoned in the dry canal bed.

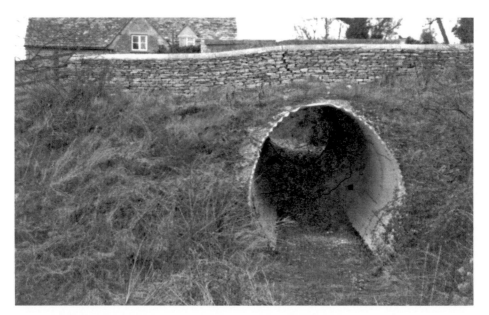

AT THAMES HEAD BRIDGE, 1962. This culvert was installed underneath the Fosse Way when it was moved over and off the original canal bridge. The wharf buildings and the stone parapet of the original Thames Head Bridge can be seen in the background.

AT THAMES HEAD PUMPING STATION SITE, 1965. These are the two houses for the enginemen. The pumping-engine house, the boiler house and the coal yard were in front of them off to the left.

THAMES HEAD PUMPING STATION WELL, 1954. The deep well was stone lined and the quoins on the right are the corner of the remaining stonework of the engine house. The railings above were to prevent accidents from the towpath down into the open well. When the water had been raised by the pump it could be directed either to the east or to the west, depending on which direction needed the water, by means of two outlets into the canal.

ACROSS TO THE THAMES HEAD PUMPING STATION SITE, 1962. The pumping engine house was demolished in 1941, but looking north across the fields to the site the buildings of the two enginemen's houses are still in position. The canal route runs almost along the skyline across the picture on the 365-foot contour line.

LYD WELL, 1962. Slightly down the valley from the pumping station, the water from Lyd well can be artesian. The well at the pumping station had many underground shafts connecting back to it, like the spokes of a wheel, and some of them were up to 100 yards long. This picture shows the amount of water that was available underground that could be drained back to the pumping station well.

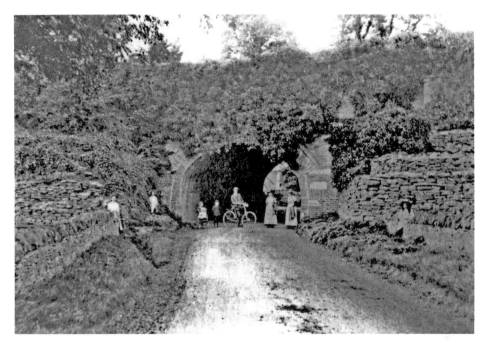

SMERRILL AQUEDUCT, 1908. The canal had to cross a small valley and also the road to Kemble. A stone aqueduct was built, with dry stone wall revetments holding the embankments on either side to carry the canal bed. This is the southern face of the aqueduct. The posed group of people gives scale to the picture, showing that the arch is probably about fifteen feet high in the centre.

SMERRILL AQUEDUCT, 1896. This view looks east along the canal bed at the aqueduct where the canal crossed over the road to Kemble. Visible is the completely dry canal bed on the summit level, and even the stop planks are in bad shape.

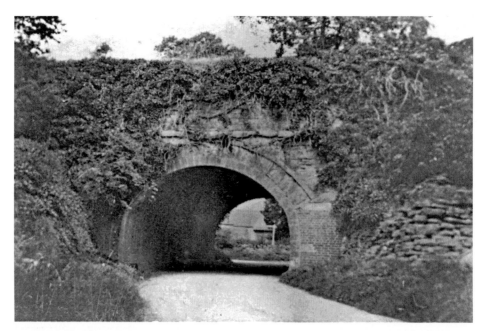

SMERRILL AQUEDUCT, 1920. Another view of the southern face of the aqueduct. Here it is a little less overgrown and does not obscure the stonework so much. Through the arch, a signpost points the way to the small road connecting with the Fosse Way Cirencester–Tetbury road.

AT SMERRILL AQUEDUCT SITE, 1931. Smerrill aqueduct was looked upon as a restriction to the growing amount of traffic on the roads and was soon demolished. The road twisted slightly as it passed through the arch and was becoming difficult for traffic. Stone blocks from the aqueduct were used to hold back the embankments on each side. These two stonemasons, Francis James and Ted Able, worked on the project.

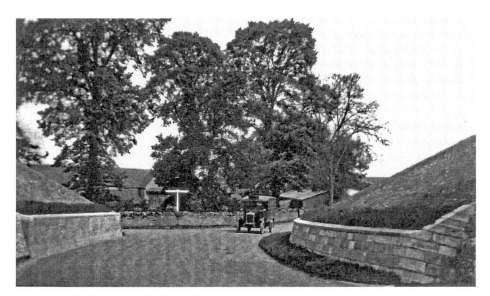

AT SMERRILL AQUEDUCT SITE, 1931. After the abandonment of the canal in 1927, the aqueduct was soon demolished. This view shows the sloped banks of the embankments neatly held up with stone blocks, probably from the original structure. Habgood's bakery delivery van is on the road going towards Kemble and Smerrill Farm buildings are beyond the fine group of elm trees.

AT SMERRILL AQUEDUCT SITE, 1962. In 1960 the road was realigned once more to take out the bends. This involved cutting back the canal embankment on the western side quite considerably. This view shows that work and the profile of the canal bed up on the top of the embankment.

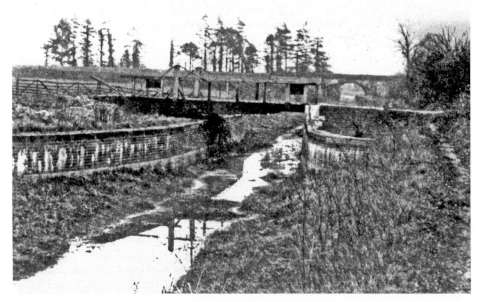

SWING BRIDGE NORTH OF THE RAILWAY CROSSING, 1896. This view looking south shows an accommodation swing bridge for access to land cut off by the canal and made worse by the building of the Cirencester–Kemble railway branch line. Once again the summit level shows very little water at this period of Trust restoration.

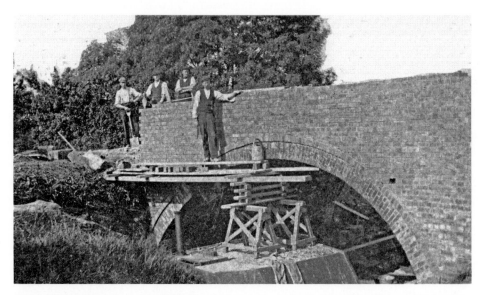

HALF WAY BRIDGE, 1908. Half Way Bridge, just south of the railway line, needed urgent repairs and was virtually rebuilt in the Gloucestershire County Council restoration. Note the trestle supports balanced on the roof of a maintenance barge. On the planks stands Mr Whiting the lengthsman from the cottage at the Sapperton Tunnel entrance.

HALF WAY BRIDGE, 1962. A very overgrown scene, but through the arch can be seen the railway line, under which the canal passed through a stone-arched bridge. This railway bridge was underfilled after abandonment to get rid of the maintenance problem. Note the stop plank grooves under the arch, which were all along the summit level and at every masonry position.

SUMMIT LEVEL BEYOND HALF WAY BRIDGE, 1962. Very few good pictures exist along some of the isolated summit level stretches. This view was looking east towards Siddington and the canal profile shows well, but rows of trees have been planted along each bank, certainly making problems for any future restoration.

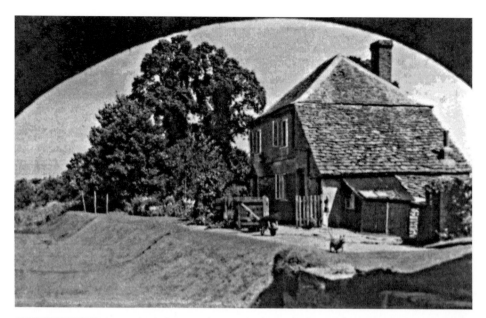

AT BLUEHOUSE, 1950. A track crossed over Bluehouse Bridge and this picture looking north through the arch shows the lengthsman's cottage. The dry canal profile is plain to see as it has been kept tidy as a lawn. Over to the left was a quarry used during the Gloucestershire County Council restoration for the extraction of clay. This was then taken away by barge or road, sometimes many miles, to use for repuddling lengths of the canal bed where leaks had occurred.

NEAR MINETY ROAD BRIDGE SITE, c. 1960. After abandonment the canal bed here became a long, linear refuse tip for the local councils. Here, near to both Minety Road Bridge and Ewen Bridge, the canal bed has been filled and is about to be covered over with top soil and returned to agricultural use.

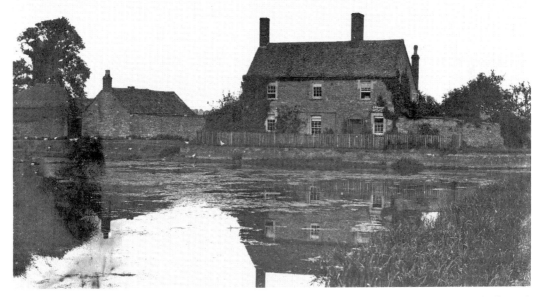

SIDDINGTON JUNCTION, 1907. This was an important place as the Cirencester branch going off north to the centre left brought the main water supply to the summit level from the outflow of the River Churn at Barton Mill. The main line of the canal crosses from the left-foreground round to the right. It was also the eastern headquarters of the canal and the agent had important duties to report. The Siddington Upper Lock down off the summit level is off to the right. In the end of the agent's house is the small shop of G. Davey, grocer & provisions merchant, a true canalside business.

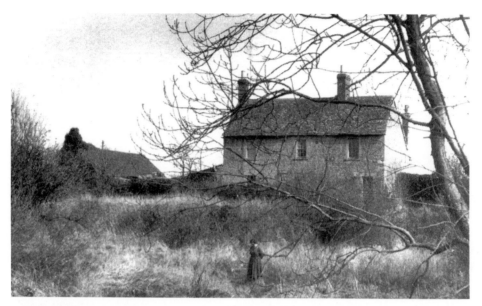

SIDDINGTON JUNCTION, 1961. Compare this with the previous picture. Here the canal has lain derelict for many years.

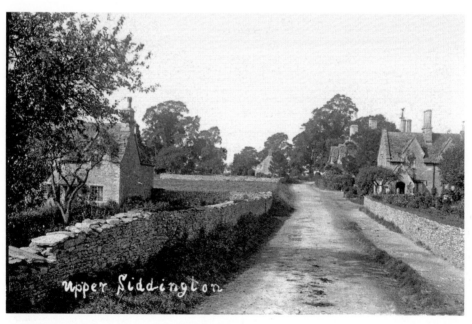

VIEW FROM POOL'S BRIDGE AT UPPER SIDDINGTON, *c.* 1905. There are very few pictures on the Cirencester branch line. This was the view from the road arch of Pool's Bridge looking west up the road and shows Siddington Lodge and Barton Farm on the right while the canal junction is on the left.

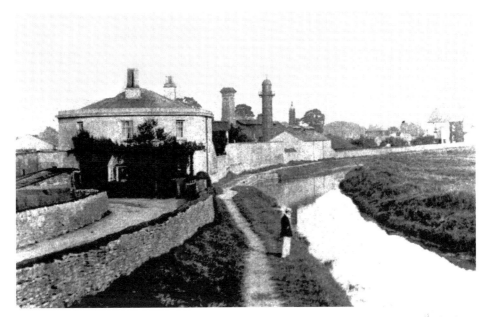

CIRENCESTER BRANCH LINE, 1907. This was the view from Chesterton Lane Bridge looking south. The canal is full of water and Cirencester gas house and gasworks are in the centre. Coal for the gasworks was brought by canal to a small wharf and unloaded across the towpath straight into the works. The building on the right in the distance was the isolation hospital, built here well away from the town.

DINNER AT THE KING'S HEAD IN CIRENCESTER, 17 November 1989. Canal Trust members and guests celebrated the 200th anniversary of the opening of the canal.

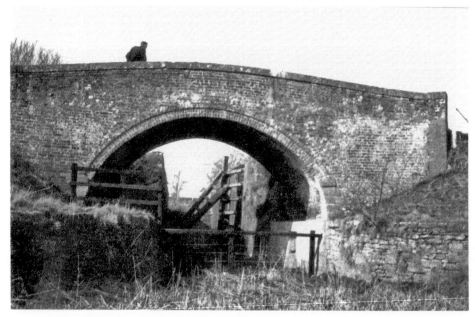

OVERTOWN BRIDGE AT UPPER SIDDINGTON, 1926. The unusable state of the canal can be easily seen in this view, but there is still one more year to go before its official abandonment in 1927. Through the arch are the broken gates and balance beams of Siddington Upper Lock. There were four locks at Siddington. All had a fall of 10 feet and were particularly heavy on water usage as the canal route dropped down to lower ground alongside the River Churn.

SIDDINGTON THIRD LOCK CHAMBER, 1962.

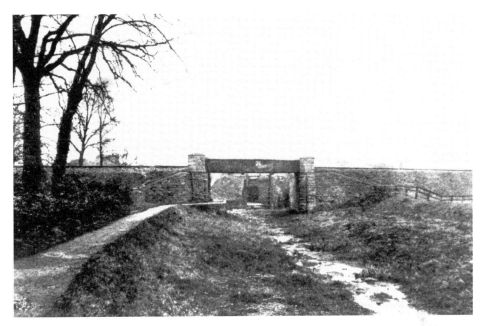

ABOVE SIDDINGTON LOWEST LOCK, 1896. The MSWJ railway line crossed the canal between the last two locks of the flight. The Siddington Third Lock can be seen in the distance through the girder railway bridge. There is no water here as this is the period of Trust restoration.

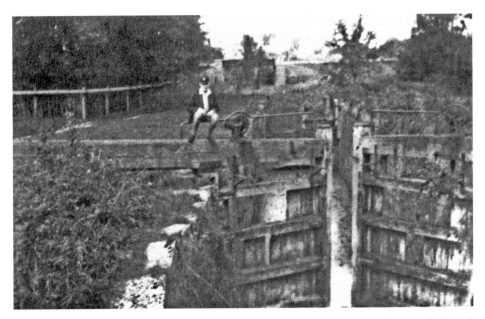

SIDDINGTON LOWEST LOCK, *c.* 1940. The fourth and last lock of the Siddington flight still with gates. In the background is the MSWJ railway line across the canal.

SIDDINGTON LOWEST LOCK SITE, 1962. The lock chamber has been filled, although some of some of the edging blocks are just showing. This picture was taken from the position of Greyhound Bridge which has been lowered and takes the road from Siddington to Ashton Keynes. The site has now been built on and presents a major problem for future restoration.

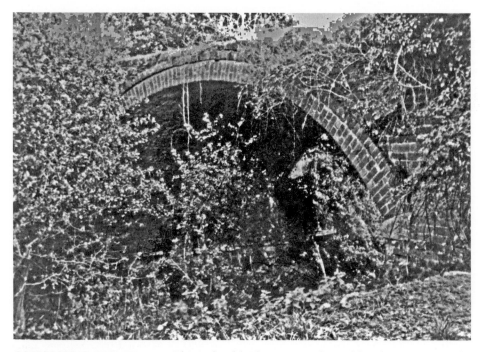

COWGROUND BRIDGE, 1965. This isolated bridge was mainly used by Plummer's Farm for access to their land cut off by the canal.

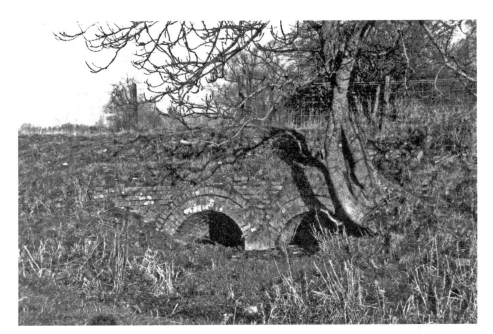

CULVERTED SIPHONS BELOW COWGROUND BRIDGE, 1962. The canal is slightly raised here as it crosses land that is subject to flooding. These two culverted siphons let water circulate freely on either side of the canal without causing damage.

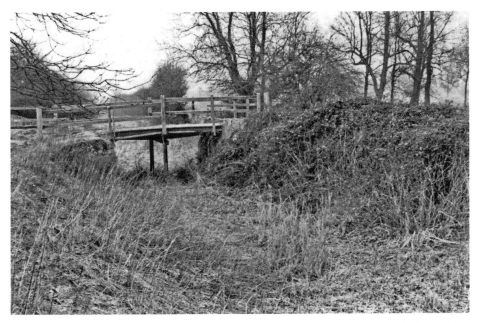

SWING BRIDGE SITE BELOW COWGROUND BRIDGE, 1962. Another access bridge to farm land in this isolated section of canal, there being no other bridges over the canal until South Cerney Upper Lock is reached approximately half a mile further down the canal. This swing bridge site is just above the canal aqueduct across the River Churn.

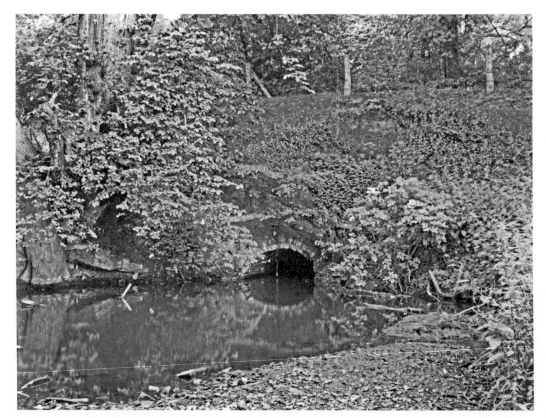

RIVER CHURN AQUEDUCT, *c.* 1955. The canal crossed the river on a substantial aqueduct about midway between Siddington and South Cerney. The fence-post line along the towpath shows the line of the canal crossing the river. With low water levels in the river there were no problems, but with higher levels the arches of the aqueduct soon blocked up and back-flooded the meadows. To solve this problem the aqueduct was removed by the Thames Conservancy.

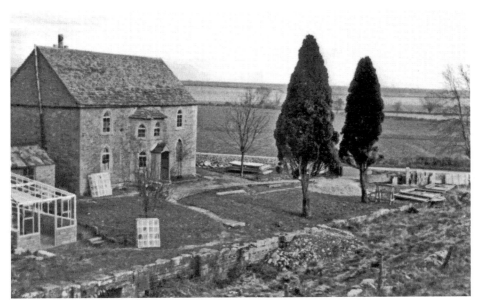

SOUTH CERNEY WHARF, 1962. The wharf at South Cerney was operated from the upper lock chamber in front of the agent's house. In this view the upper lock chamber is being used for disposing of the rubble etc. from the renovation of the wharf house. There were three locks at South Cerney, because the canal quickly dropped down a slope, and large circular pounds were necessary between them. Trade from the wharf would have been mostly coal, agricultural materials and bricks from the nearby brickyard.

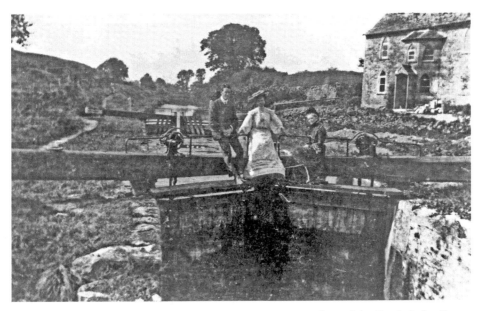

SOUTH CERNEY UPPER LOCK AND WHARF, c. 1905. Members of the Goodwin family can be seen sitting on the bottom gates of the lock. There is plenty of water but the lock is full of weed, an indication that there was very little traffic through here.

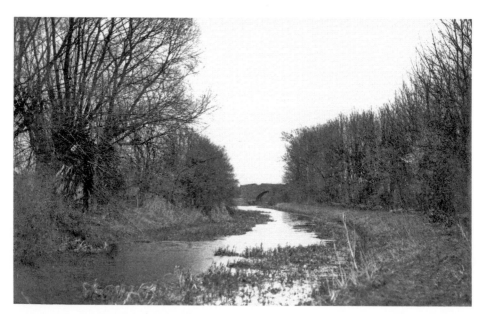

CRANE BRIDGE, 1947. This bridge was also known as Northmoor Lane Bridge or locally as Minute Lane Bridge. A small lane down from the Fosse Way to South Cerney village crossed the canal here.

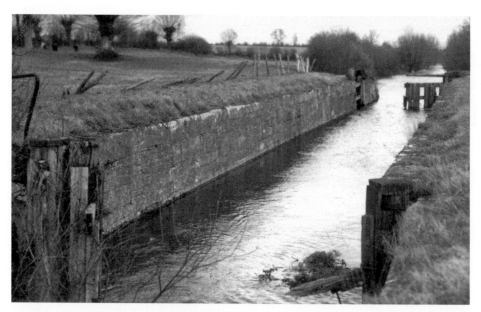

BOXWELL SPRING LOCK, ALSO KNOWN AS SHALLOW LOCK OR LITTLE LOCK, 1947. This lock was put in as an afterthought by the company, in order to lower the canal by a few feet. By doing so the water from the springs below could be channeled into the canal to give extra water to operate the two deep locks further down the canal. These locks were Humpback and Wildmoorway, both with a fall of 11 feet. In this photograph the lock's gates are broken, but it is beautifully built using cut limestone blocks.

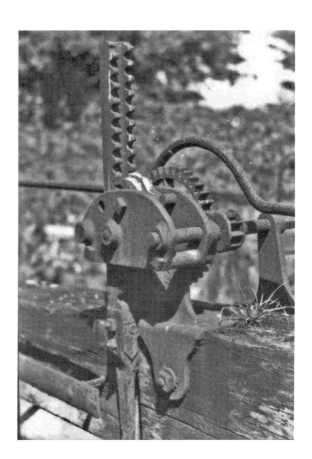

HUMPBACK LOCK PADDLE GEAR, 1949. Shown here is the ratchet and pawl mechanism for the paddles on the bottom gate.

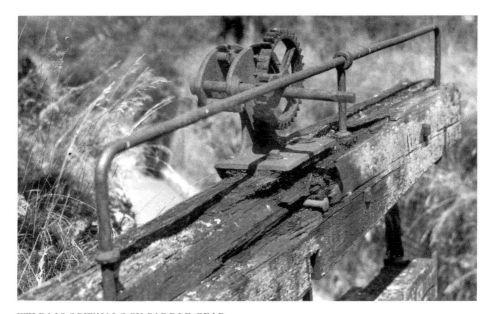

WILDMOORWAY LOCK PADDLE GEAR, 1949.

WILDMOORWAY LOWER LOCK, 1962. This was taken from Wildmoorway Bridge and shows the 11-foot-deep lock. There were only four locks of this depth on the canal, the other three being Wallbridge Upper Lock, Bourne Lock and Humpback Lock. The correct operation of this lock and side pond was so important that a lengthsman was based here.

WILDMOORWAY LOCK SIDE POND, 1974. A side pond was built just down off the towpath so that less water was used to operate the lock. About half a lock of water was saved at each use of the lock by emptying and filling the side pond. This picture shows the hinged cast-iron lid in the corner of the side pond base. By opening and closing it in conjunction with a similar lid in the side wall of the lock chamber, the side pond either received or returned water to the lock chamber. This sort of operation would have been one of the important jobs for the lengthsman to carry out here.

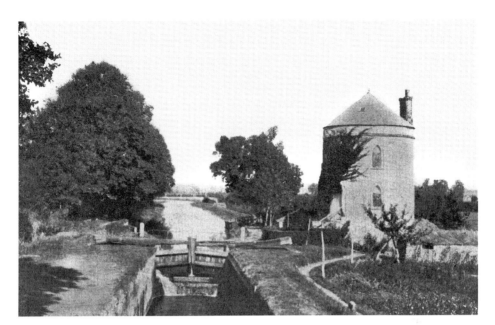

CERNEY WICK LOCK AND ROUND HOUSE, c. 1895. The canal runs almost due south here. The lock gates and balance beams are in bad condition although there is plenty of water held back. This is the period of the Trust restoration. The round house is the third such lengthsman's cottage along the canal route.

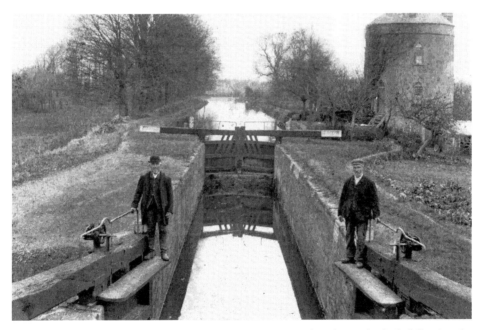

CERNEY WICK LOCK AND ROUND HOUSE, c. 1905. This shows the lock following the Gloucestershire county council restoration programme. It is probably the lengthsman from the round house who is standing on the right-hand lower gate. The other man, in the bowler hat, is possibly the foreman from the gang that carried out the restoration here.

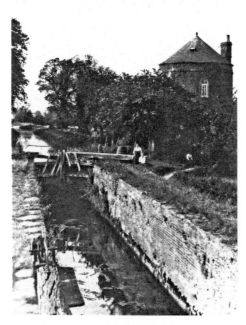

CERNEY WICK LOCK AND ROUND HOUSE, *c.* 1925. About twenty years after the previous picture the whole scene was back to dereliction. The lock would have been impossible to operate and yet it is not to be officially abandoned for a few more years.

CERNEY WICK LOCK AND ROUND HOUSE, 1947. The lock is now overgrown and the balance beams have been sawn off, but the paddle gear survives. The round house became a weekend retreat cottage and because of that it remains in good shape.

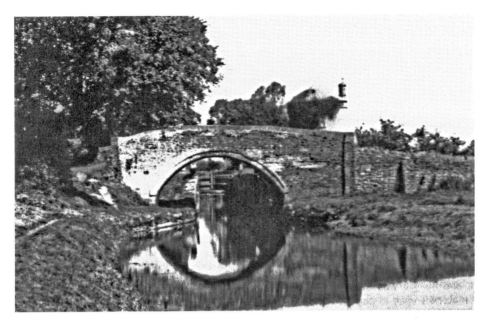

CERNEY WICK BRIDGE, *c.* 1910. This bridge, which carried a small road from the Fosse Way to the village of Cerney Wick, crossed the canal below the lock. The lock can be seen through the arch of the bridge, which was demolished soon after the abandonment.

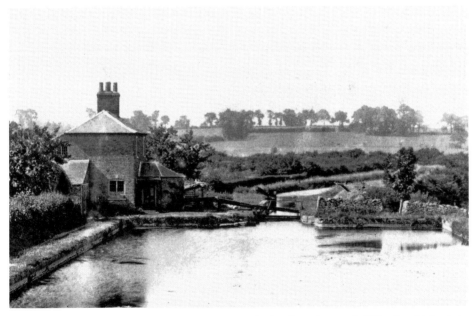

LATTON BASIN, *c.* 1895. A stone-lined basin was built where the North Wilts Canal joined the Thames & Severn Canal. This formed a valuable link through to the Wilts & Berks Canal. From the Thames & Severn Canal a short aqueduct over the River Churn took the canal into this basin. At the end were the toll-house and two stop locks into the North Wilts Canal, as both companies jealously guarded their water supplies.

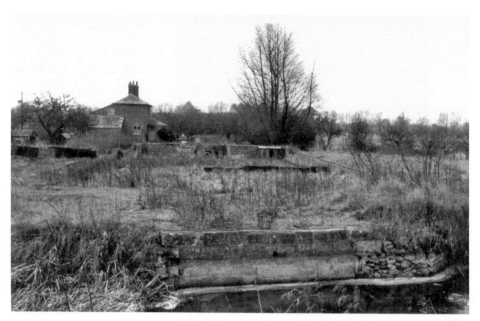

LATTON BASIN, 1962. If it weren't for the toll house it would be difficult to see that this is the same scene as that in the previous photograph. Over the years the basin has become overgrown and the associated bridges on the canal have been demolished, but in the foreground can be seen the site of the aqueduct over the River Churn, which came off the canal into the basin.

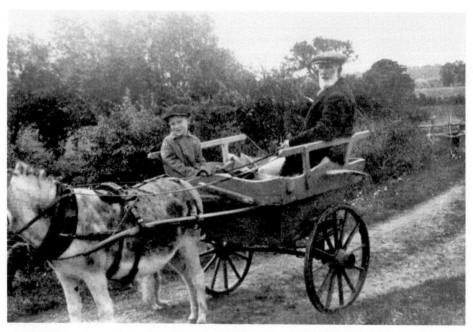

AT LATTON BASIN, 1918. Alfred Howse was the lock-keeper at the basin and he also had a smallholding. He is seen here on the track with his donkey cart taking some of his produce to Cricklade market.

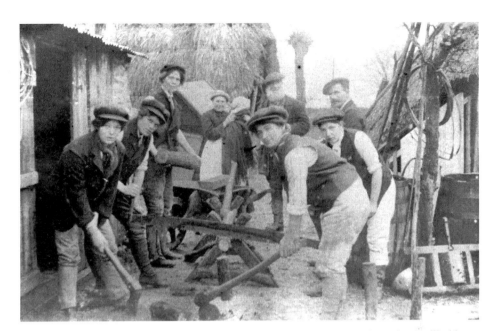

AT LATTON BASIN, *c.* 1915. Alfred Howse and his large family at work on the smallholding.

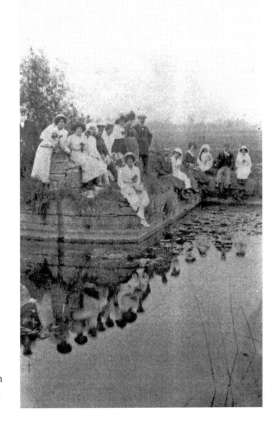

AT LATTON BASIN, 1915. A Howse family wedding party; guests are sitting on the basin wall close to the point at which the North Wilts Canal leaves the basin. Off to the left was the stop lock. The wedding was that of Walter Godwin (the soldier in uniform, seated fifth from left) to Nell Howse (sixth from left).

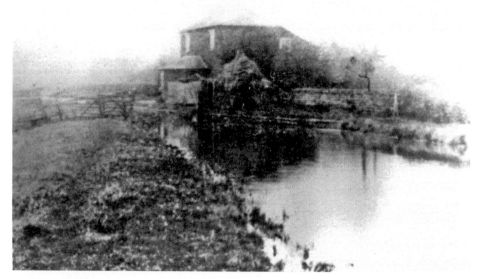

LATTON BASIN TOLL-HOUSE, *c.* 1895. This is not a very good picture but was thought worthy of inclusion. This view is from the North Wilts Canal, looking north back towards the basin with the toll-house on the right. The stop lock is behind the hurdle fence on the left.

LATTON BRIDGE SITE, 1962. This bridge was also known as the Swindon Road Bridge where the Fosse Way road from Cirencester to Swindon crossed the canal. The humpbacked bridge became a hazard for the increasing road traffic and was demolished in 1928, one of the first structures to be demolished after the abandonment in 1927. This view shows the canal profile looking back up the canal from the site. The sharp curve in the canal at this point was to avoid Latton Mill, which is off to the left.

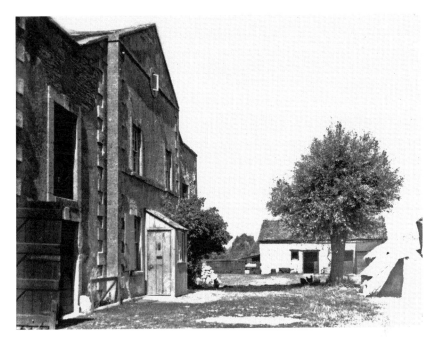

CRICKLADE WHARF, 1949. This building was the warehouse and the agent's house. There were three of this style of building on the canal, the others being at Cirencester and Kempsford. The agent's house, with the porch, was in the central section, surrounded on three sides by the warehouse. The canal is off to the right and this building fronts onto the wharf area. Beyond the tree were some stables.

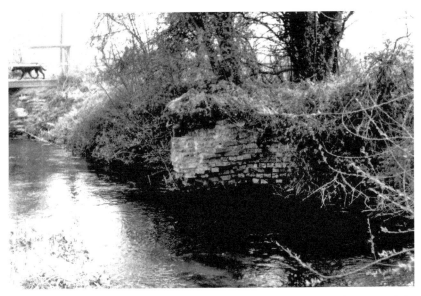

The Ampney Brook Aqueduct, 1977. Above Eisey Lock a small aqueduct carried the canal over the Ampney Brook. This view shows the few remains of the north face of the aqueduct. The canal crossed right to left and the footpath bridge on the left still maintains the towpath line.

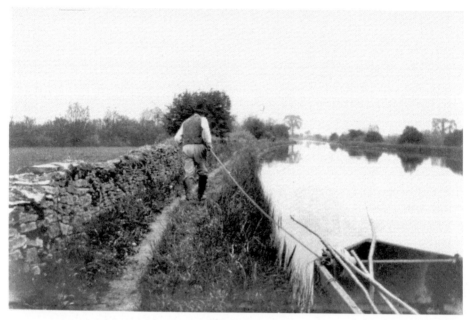

NEAR EISEY FARM BRIDGE, 1911. The lengthsman from Eisey Lock cottage is towing his maintenance work boat on the canal above the bridge. There is plenty of water here but commercial traffic would probably have ceased here. Eisey Farm Bridge gave access across the canal to the large complex of Eisey Farm.

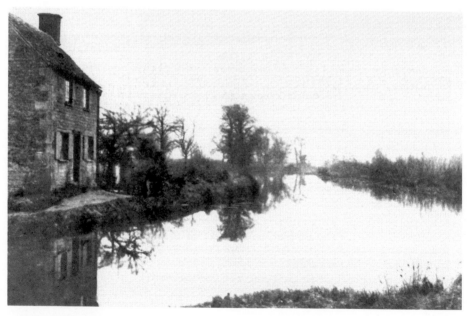

ABOVE EISEY LOCK, 1896. The lock was off to the left below the cottage, built in 1831, where a lengthsman was based. This view is looking up the canal and there is plenty of water even at this period of Trust restoration. Due to its isolated location this cottage could only be reached by canal or towpath.

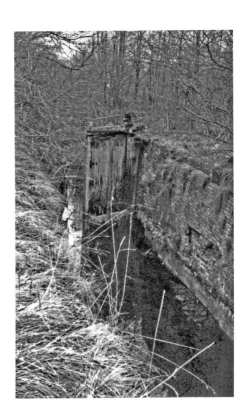

EISEY LOCK, 1962. This lock is in a very isolated place where the canal route crosses the large expanse of flat country of the River Thames plain. This view shows the lock chamber with the bottom gates and still complete with the handrail and paddle gear.

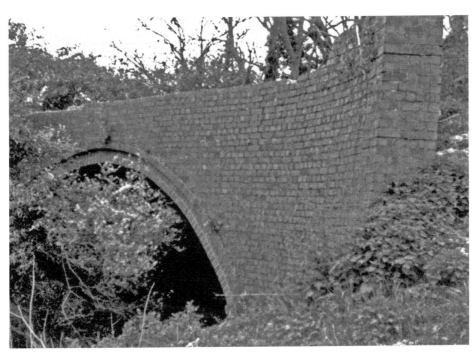

RUCKS BRIDGE, 1975. Also known as Alex Farm Bridge it gives access across the canal to Alex Farm. The parapets have been removed so that wide farm machinery can use the bridge.

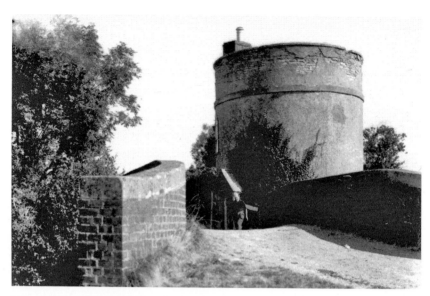

MARSTON MEYSEY BRIDGE AND ROUND HOUSE, 1949. The humpbacked bridge is emphasised here by the surrounding flat countryside just a short distance from the River Thames. A small wharf was situated by the bridge and round house and it mainly dealt with agricultural materials. It is a very isolated site, but the round house has not yet fallen into disrepair although some of the stucco plaster is starting to come away. This is the fourth such round house and it would have been occupied by a lengthsman/agent with not much trade to deal with.

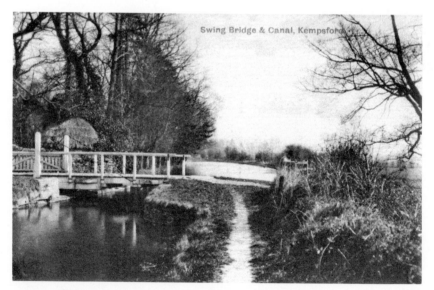

KEMSPFORD SWING BRIDGE, c. 1905. From Marston Meysey down to Kemspford is about two miles and the canal route was across the flat countryside, never very far away from the River Thames. At this swing bridge the river is less than 100 yards away but it was not a suitable place to link into the river. This bridge gave access to land cut off between the river and the canal.

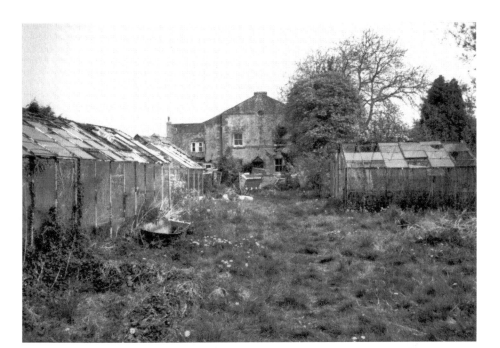

KEMPSFORD WHARF, 1999. This is the third and last of this combined style of agent's house and warehouse building. It is now seventy years since abandonment and the site has had many uses over these years but the building survived. The canal was behind the camera and the entrance to the wharf was just beyond the greenhouses on the left, down a lane from the village.

KEMPSFORD WHARF, 1962. A scene of complete dereliction. The view is from the towpath side opposite the wharf which is over to the right across the canal where the goose is. There are no edging stones to the wharf but some appear in a pile on the right. It was near the wharf that the Whelford feeder joined the canal.

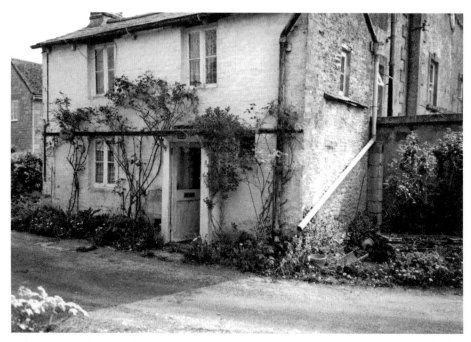

OUTSIDE KEMPSFORD WHARF, 1999. The agent's house and warehouse can be seen over the wall on the right and this lane leads into the wharf through the entrance gate and pillars. This small, cottage built against the wing of the warehouse, was once a beer house just outside the wharf and was probably well used by the bargees.

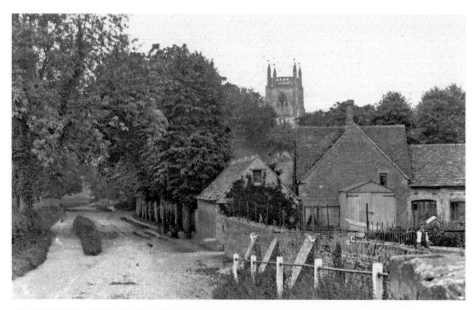

KEMPSFORD CHURCH TOWER FROM THE CANAL BRIDGE, c. 1915. This view was taken from the arch of the road bridge looking towards St Mary's Church. The small timber wharf was just to the left, where the man is standing.

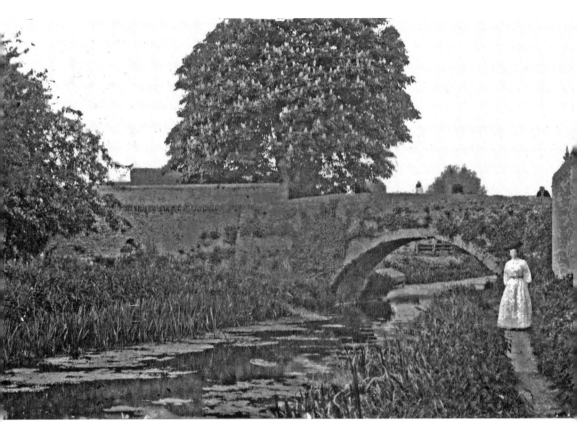

KEMPSFORD BRIDGE, *c.* 1905. Just down the canal from the wharf was Kempsford Bridge carrying the road from Kempsford to Hannington. The bridge was demolished soon after the abandonment in 1927. A small wharf for timber etc. was established here and can be seen on the left through the arch of the bridge.

THE WHELFORD FEEDER, *c.* 1925. The feeder came from the River Coln below Whelford Mill Bridge, and went across to join the canal at Kempsford Wharf. The feeder is seen here coming round the corner in front of Pope's Court.

THE WHELFORD FEEDER, *c.* 1930. The feeder was about 1¾ miles long and brought a steady supply of water to the canal which was needed to help run the Dudgrove Double Lock and then the last lock at Inglesham. The feeder is seen here in front of some cottages alongside the road from Whelford to Kempsford. Once the feeder was not needed, after the abandonment in 1927, it was maintained by the landowner as a useful fishing stream.

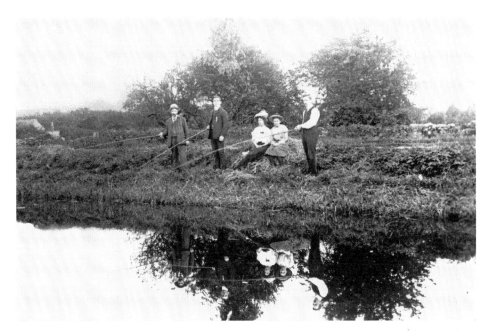

NEAR KEMPSFORD, *c.* 1910. This was the Woodward family fishing the canal somewhere below Kempsford.

HAMFIELD BRIDGE, 1962. For about one mile below Kempsford the canal goes due east. This is probably one of the most isolated sections as there are no other communities along the route or near to it. There are several accommodation bridges for farming access and Hamfield Bridge is one of these. It was also known as Deep Cutting Bridge or Brazen Hill Bridge.

SWING BRIDGE BETWEEN HAMFIELD AND DUDGROVE BRIDGES, 1980. Remarkably, after more than fifty years the swing bridge and railings remain *in situ*, probably because it was easier to fill the canal bed alongside for the heavy farm machinery to cross.

BELOW DUDGROVE BRIDGE, 1962. This was another of the isolated accommodation bridges for access to Dudgrove Farm land. As with most of these bridges below Kempsford, it has been demolished and the site filled with hardcore so that farm machinery can cross the canal bed easily. This view is looking east down the long, straight section to Dudgrove Double Lock.

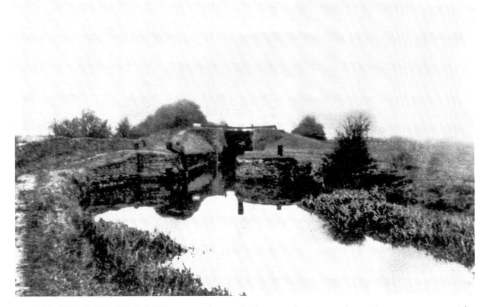

DUDGROVE DOUBLE LOCK, 1896. A good picture of the canal out in open countryside, showing the well-built upper lock chamber on the skyline and the hastily and poorly built lower lock chamber in the foreground.

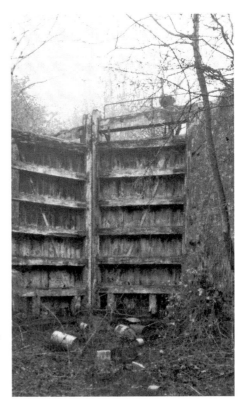

DUDGROVE DOUBLE LOCK, 1962. This shows the middle gates of the double lock chambers. They remained here thirty-five years after abandonment. The canal route had originally been designed so that it would join the River Thames below the main top lock, but after reconsideration a smaller lower chamber was hastily built to lower the canal a further 2½ feet in order to join the river lower down at Inglesham, where the River Coln joined the River Thames. The water from the River Coln effectively doubled the flow and depth of water, making navigation much more secure. It also avoided a length of the river that had a very tortuous course.

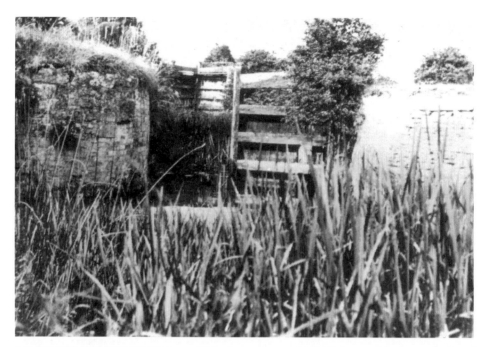

DUDGROVE DOUBLE LOCK, 1923. This shows the roughly built lower chamber with one of the bottom gates in place. Beyond are the middle gates shared by the two chambers. This picture shows the totally unusable state of the canal, though it would yet be four years before it was officially abandoned.

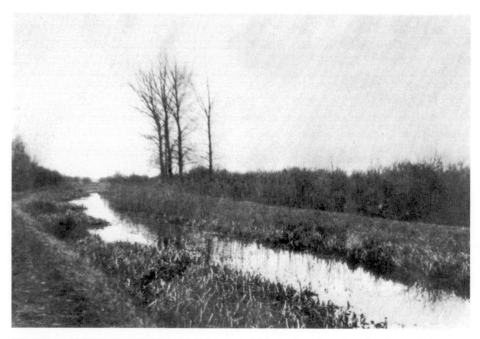

BELOW DUDGROVE DOUBLE LOCK, 1896. This is the short length of canal down to Inglesham Lock and the River Thames.

ABOVE INGLESHAM LOCK, 1962. This photograph was taken from the canal bed looking west up towards Dudgrove on a misty winter day. Behind the camera the canal opens out into a diamond-shaped basin, which was originally intended to be the working terminus wharf of the canal above Inglesham Lock. This basin was used for over twenty years until trade demanded a more suitable wharf.

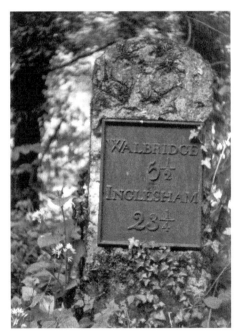

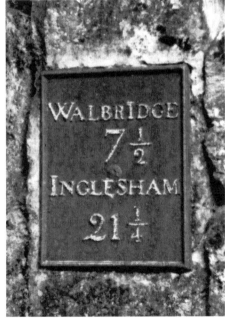

ABOVE LEFT: MILESTONE WITH PLATE BELOW BAKER'S MILL, 1962.

ABOVE RIGHT: MILESTONE WITH PLATE AT SAPPERTON TUNNEL ENTRANCE, 1956.

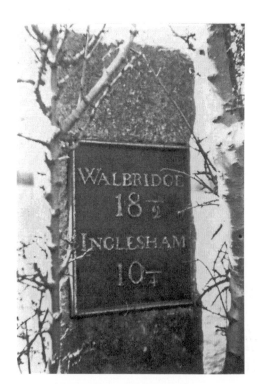 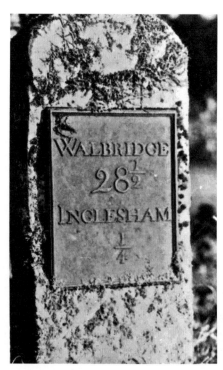

ABOVE LEFT: MILESTONE WITH PLATE AT WILDMOORWAY, 1962.

ABOVE RIGHT: MILESTONE WITH PLATE AT INGLESHAM, 1947.

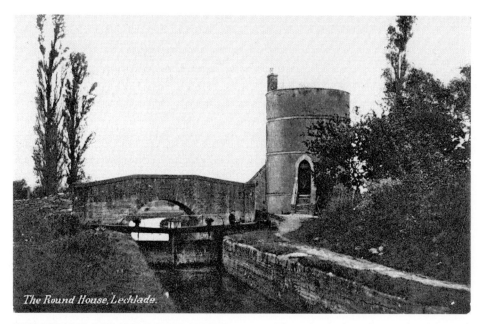

INGLESHAM LOCK AND ROUND HOUSE, *c.* 1905. This is last lock on the canal and through the bridge is the River Thames. This round house is the fifth and last along the canal route.

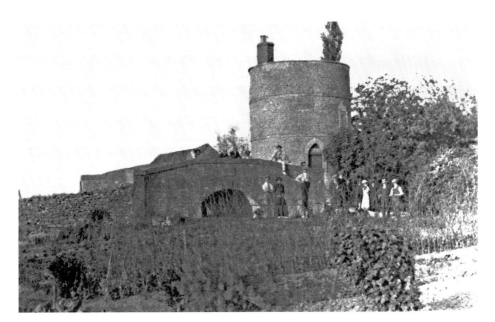

INGLESHAM BRIDGE AND ROUND HOUSE, *c.* 1910. A charming picture with a group of posed people. In the foreground are some gardens alongside the lock chamber, probably tended by the lengthsman who was based here.

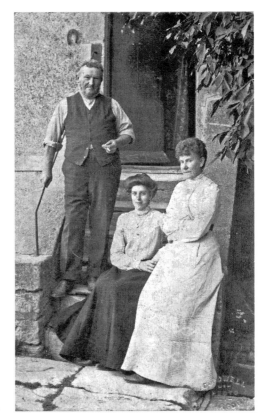

AT INGLESHAM ROUND HOUSE, *c.* 1900. Mr John Rawlings was the lengthsman. He is seen with his daughter and wife on the steps up to the front door.

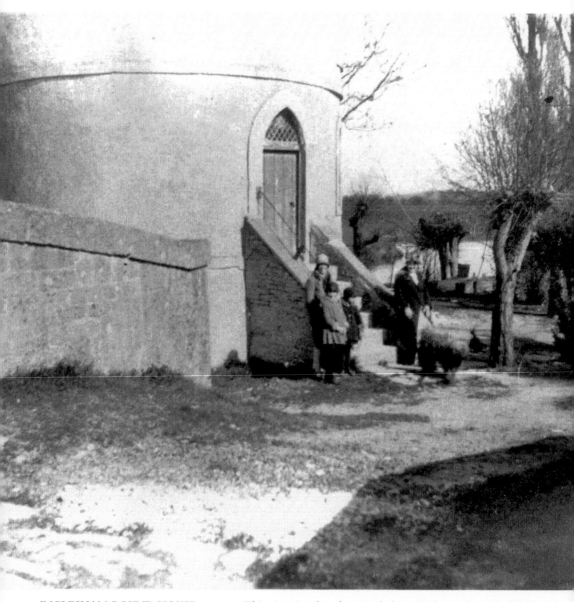

INGLESHAM ROUND HOUSE, *c.* 1920. This view is taken from Inglesham Bridge at the tail of the lock. The water in the background is the River Thames coming round behind the round house. The towpath crossed the bridge here and went between the bridge parapet and the steps up to the door before crossing over the Thames.

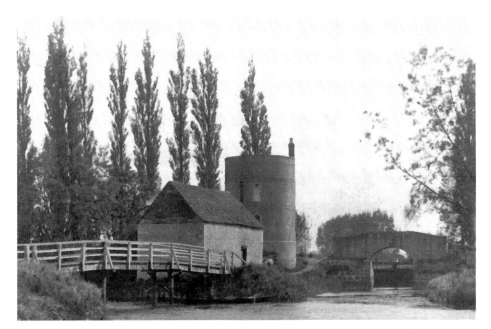

AT INGLESHAM, *c.* 1910. From the left was the towpath bridge over the River Thames, the small warehouse, the round house and Inglesham Bridge with the last lock visible through the arch. These distinctive poplar trees occur on many photographs of the area.

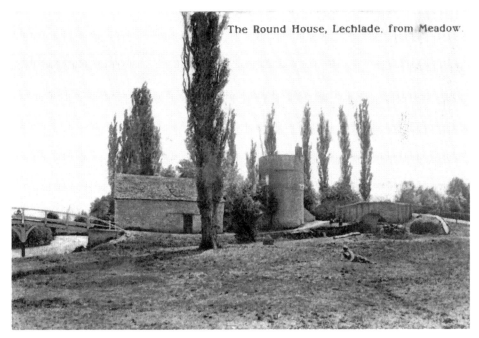

The Round House, Lechlade, from Meadow

AT INGLESHAM, *c.* 1915. A similar scene to the previous picture but taken from the small meadow alongside. Note the replacement towpath bridge over the River Thames on the left.

River Thames

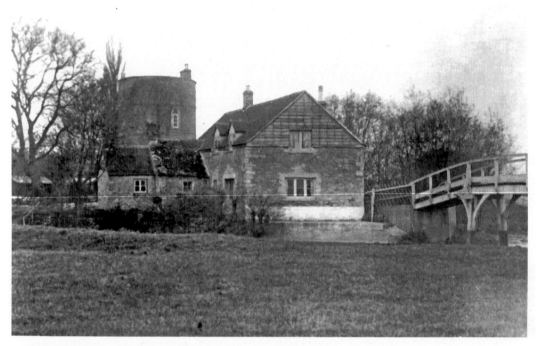

AT INGLESHAM, *c.* 1930. This view was taken from the opposite bank of the River Thames and shows how the small warehouse has been converted into accommodation. The river cuts across left to right beyond the meadow in the centre.

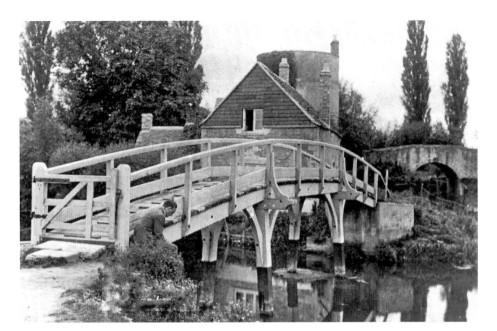

AT INGLESHAM, *c.* 1930. a fine view of the replacement towpath bridge over the river. The photograph is by the Simms/Packer studio of Chipping Norton – perhaps the man visible is Simms or Packer himself? Note that the water level in the River Thames is very low.

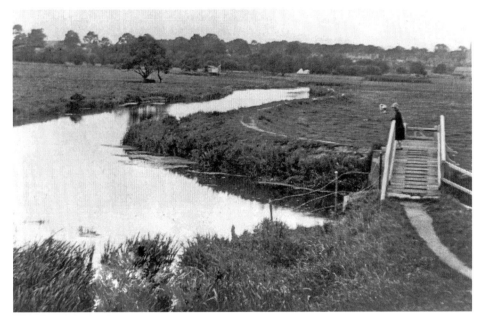

BELOW INGLESHAM BRIDGE, *c.* 1930. This was the view towards Lechlade from the bridge with the towpath crossing the river on the right. Just off to the left the River Coln joins the River Thames and effectively doubles the flow and depth of water, making this the ideal place for the canal to join. The extra water almost guarantees unimpeded navigation on the river as it meanders through the meadows to Lechlade.

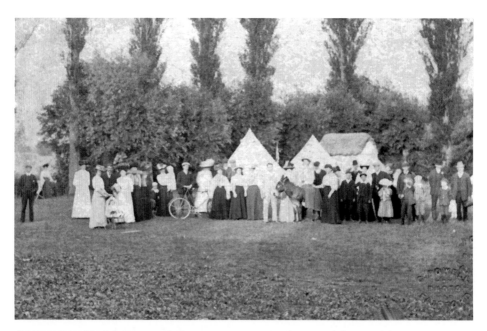

AT INGLESHAM ROUND HOUSE FIELD, *c.* 1900. At the rear of the round house there was a triangular meadow that was often used by various groups as a meeting place. This was possibly a Sunday gathering of a religious group. Tents were often put up for meetings.

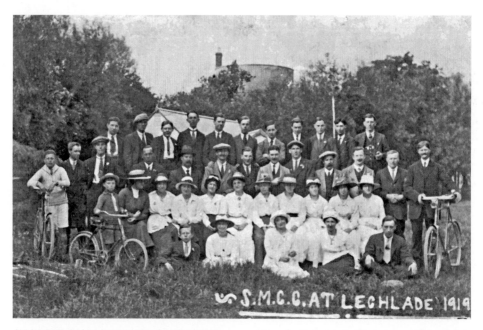

AT INGLESHAM ROUND HOUSE FIELD, 1919. Here the Stratton St Margaret cycling club is using the field as a meeting place. Note the roof of the round house above the trees and also a more permanent wooden shelter in the field.

INGLESHAM ROUND HOUSE FIELD, *c.* 1920. The field now has a number of shelters that could be used by groups, as interest in the canal and riverside field increases.

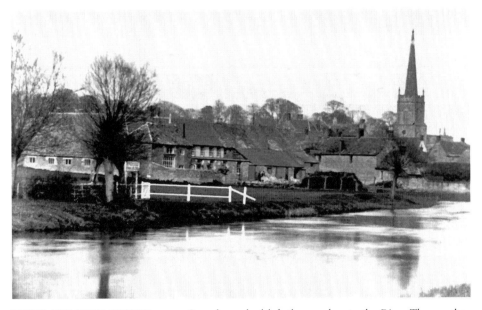

LECHLADE FREE WHARF, 1907. Once boats had left the canal onto the River Thames they would soon have approached Lechlade. The free wharf was just above the canal company premises at Parkend Wharf, and is seen here with a pile of stone and a heap of timber, with the end-on entrance by the wall on the right-centre.

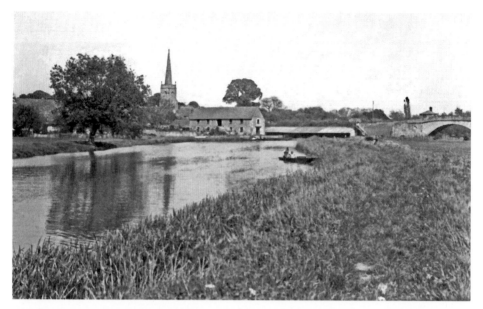

APPROACHING PARKEND WHARF, 1930. The canal company soon realised after a few years that their wharf above Inglesham lock was not suitable for their trade either in size or accessibility. They then purchased the established Parkend Wharf at Lechlade. It was just above the Halfpenny Bridge and is seen here in the centre. Buildings on the wharf included a warehouse, an agent's house with offices and a salt store, plus a good river frontage and a long side dock.

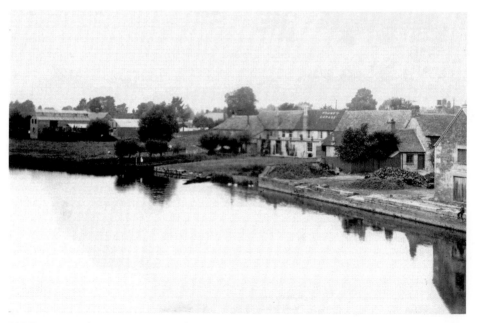

PARKEND WHARF, c. 1920. A good view of the wharf taken from Halfpenny Bridge over the River Thames. There are large piles of coal on the wharf and note that a few of the wharf edging stone blocks have been removed to make unloading of barges easier. The free wharf is just beyond Parkend Wharf, directly in front of the building with 'Young's Garage' painted on the roof.

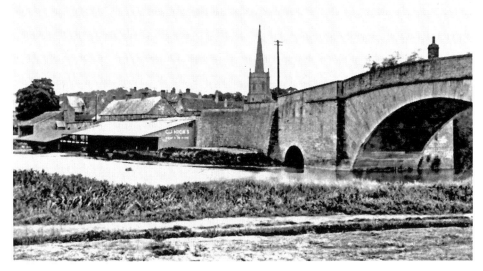

PARKEND WHARF AND HALF PENNY BRIDGE, *c.* 1905. In Edwardian times pleasure boats were well established at the wharf and here C. J. Hicks is advertising boats for hire from the open-fronted building on the long side dock. Halfpenny Bridge took the road from Lechlade through to Highworth and Swindon.

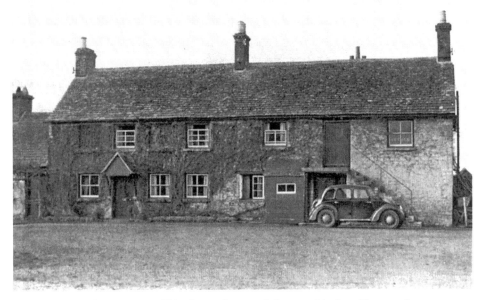

PARKEND WHARF, *c.* 1950. This shows the agent's house with the offices up the stone steps over the salt store behind the car.

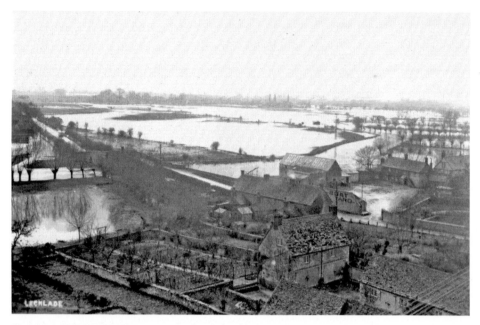

FLOODS AT LECHLADE, *c.* 1925. Floods could seriously impede navigation, especially on the River Thames as shown in this view taken from the church roof. The canal joined the river back by the poplar trees in the centre background, but the course of the river and the towpath are lost in the floods. Parkend Wharf is in the centre.

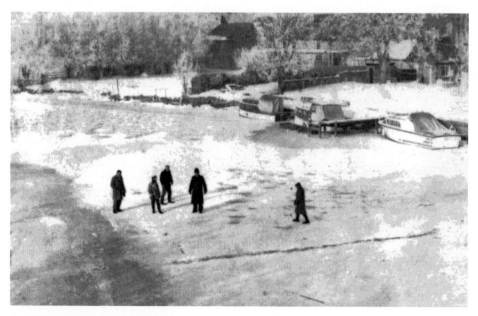

WINTER SCENE AT LECHLADE, 1963. Ice could also impede navigation and it would easily form on slow moving canal waters. In 1963, looking down from Halfpenny Bridge by Parkend Wharf, the Thames has frozen. The ice was particularly thick and boats remained locked in for many weeks.

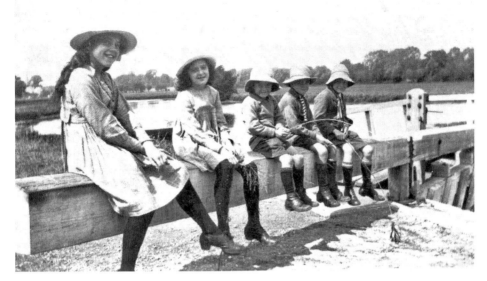

ST JOHN'S LOCK, *c.* 1920. This is the first lock on the river that the barges would encounter after leaving Parkend Wharf at Lechlade. Here a happy group is sitting on one of the balance beams on a sunny summer's day.

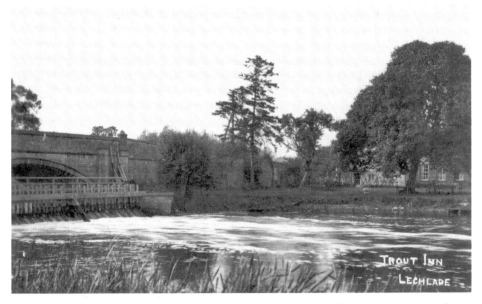

ST JOHN'S LOCK WEIR, *c.* 1935. This was originally the site of a flash lock on the river, but it was later altered to a weir when St John's Lock was built. The Trout Inn can just be seen behind the trees on the right.

Acknowledgements

First and foremost we acknowledge the Photographic Collection, which included these two canals, assembled many years ago by Stanley Gardiner, Lionel Padin, Mike Mills and Edwin Cuss. This collection is now partly with Mike Mills and Edwin Cuss.

Also many of the new photographs used in this volume have come from our personal collections.

But many people have helped us make these collections over the last forty years or so and they include:

H. Beard • D. Burton • Cotswold Canals Trust • G. Drummond • B. Gegg
Gloucestershire Archives • P. Griffiths • M.A. Handford • H. Household
B. Howse • J. James • F. Lloyd • S. Matthews • H. McKnight • J. Nelson
M. Riddihough • C.H.A. Townley • J. Tucker • D. Viner • R. J. Whiting

Without their help it would not have been possible to put together Volume One and Volume Two and equally this final volume of *The Stroudwater and Thames & Severn Canals From Old Photographs*.